A tree absorbs abundant nutrients and water through its long roots,
and together these enable the tree to thicken its trunk,
to grow branches and leaves to its heart's content,
and, at times, to produce flowers and fruit.

We think of a tree as a form embodying absorption and proliferation,
the dividing line between the two being ground level.
We think of our creative work as a form of absorption and proliferation too,
always changing with the times.

What we aspire to is, with tender care,
to grow one tree after another until, eventually, they become a forest.

KIGI

「木」は、長い根から、たっぷり養分水分を吸収し、
幹を太くし、思いっきり枝葉を広げ、
時に花を咲かせ、実を結ぶ。

その木の姿は地面を境に〈吸収〉と〈拡散〉をしている
ひとつのカタチなのではないだろうか。

そして私たちのクリエイションも
時代とともに〈吸収〉と〈拡散〉をしている
ひとつのカタチなのだと思う。

一本ずつ丁寧に木々を育てて
　　　　　やがて、森にしていきたい。

植原亮輔
Ryosuke UEHARA
Yoshie WATANABE
渡邉良重

キギ

R & Y

VICTORIA AND ALBERT MUSEUM _ wall clock _ time paper colaborated with v&a (2010) R.Uehara & Y.Watanabe

R & Y

R & Y

UROGA SPECIMEN OF TIME

時間の標本

クライアントワークであるデザインには多くの制約がつきものです。一方で制約を解除してつくる作品制作は、新しい体験や方法論を探ることでもあります。「時間の標本」という作品は、2007年に東京都現代美術館で開催された展覧会「SPACE FOR YOUR FUTURE」に参加した時に生まれました。数多くある作品の中のひとつの展示だったこともあり、空間全体で作品世界を表現すべく、2008年、より作品を充実させ、個展というかたちでAMPG（*）にて改めて展示しました。古い本の見開きに蝶を描き、その裏ページに蝶の裏も描く。そして、描いた周りをカッターで切り抜いていくと、製本された紙が持つ"張り"で蝶の羽根が自然と浮き上がっていきます。それはまるで蝶が生まれる瞬間のように思えます。古書はおそらく一度は誰かが手にしたもので、かつて本が開かれたその時そこに蝶が止まった瞬間があったかもしれません。本は閉じられ、再び開かれるとき蝶は命を吹き返します。蝶は風景を美しく変える、幸せの象徴でもあると考えています。個展では、本に封じられた蝶を開閉する映像作品、阿部海太郎さんによる音響、アルゴリズムで構築された蝶が投影され空中を飛翔する作品も同時に展示しました。2012年4月、草間彌生さんや奈良美智さんらも参加するヴァンジ彫刻庭園美術館での展覧会「庭をめぐれば」に「時間の標本」を出品しました。

*Azuma Makoto Private Gallery(AMPG)は、フラワーアーティスト東信さんが自身の作品を発表するために2007年4月から2年間限定で開設していたギャラリーです。

Specimen of Time When performing work for clients, many restrictions apply. But creating pieces while free of those restrictions also gives us the opportunity to deepen our experiences and methodologies. Specimen of Time was created when we were included in "SPACE FOR YOUR FUTURE," a 2007 exhibition held at the Museum of Contemporary Art Tokyo. Displayed as one piece among many, we also wanted the chance to use our space entirely in order to express the piece's world. Fortunately, in 2008, we were able to redisplay as a single, fuller exhibition at AMPG*. A butterfly was painted on the two open pages of a book, and on the reverse of those pages the butterfly's reverse was also painted. When the outline of the drawing was cut out with a paper cutter the tension of the pound pages caused the butterfly's wings to float up, naturally. That moment of release is like watching a butterfly being born. Or as if, somewhere, somebody had left an old book open and, for a moment, a butterfly had just alighted there. Should the book be closed and then reopened, life could be breathed into that butterfly once more. To us, a butterfly is a symbol of beauty and happiness. The exhibition included video of the books, with sealed butterflies, opening and closing, music by Umitaro Abe, and an image of a flying butterfly, created by algorithm, which was projected into the air. In April, 2012, Specimens of Time is also being displayed in "Strolling the Garden" ("Niwa wo Megureba") an exhibition at The Vangi Sculpture Garden Museum which includes artists such as Kusama Yayoi and Nara Yoshitomo.

*Azuma Makoto Private Gallery (AMPG) was a limited time two year gallery established in April, 2007 in order for flower artist Makoto Azuma to display his own pieces.

PRIVATE_works_*specimen of time* 〈2008〉 R.Uehara & Y.Watanabe

欲望の茶色い塊

私たちが初めて監督した映像作品。カメラマンは辻佐織さん、音楽は阿部海太郎さん。深澤直人さんがディレクションした21_21デザインサイトの第一回企画展「チョコレート」に参加し、空間インスタレーションとともに上映しました。台詞は一切なく、劇中は音楽だけが流れています。ひとつ目の作品は、帽子屋とネクタイ屋のチェスゲームの物語。グラスに見立ててウィスキーが注がれたチョコレートのルークと、ウィスキーボンボン仕立ての他の駒を並べ、二人の男は試合を開始します。相手の駒を取るたびにウィスキーボンボンの駒を食べ、止まらなくなった男たちは、どんどん酔っ払っていきます。もうひとつの作品は、男女のディナーの席。テーブルには、銀紙で包まれ、銀食器となったチョコレートのフォークにグラス、お皿が並んでいます。運ばれてくるイチゴやバナナやナッツを、銀紙を剥がしながら食器もろともひたすら食べていくというお話。どちらのストーリーも描かれているのは欲望に溺れてしまう人間です。酒や賭け事、恋愛、そして何より甘いものを食べるという抑えがたい欲望を表現しています。それまで映像の制作経験のない私たちが、わずか6分のショートフィルム2本を撮るために、役者を始め、映像制作のプロフェッショナル、チェス協会の方など、非常に多くの方々にご協力いただき完成させることができた作品です。

Brown Morsels of Desire Our first time directing on film. Camera work was performed by Saori Tsuji and music was composed by Umitaro Abe. The final pieces were included in 21_21 Design Sight's first exhibition, "Chocolate," which was directed by Naoto Fukasawa. They were displayed within an installation. The film features no dialogue, only music. The first piece is the story of a chess game between a hat maker and a necktie maker. Whiskey is poured into a chocolate rook which resembles a glass while the other pieces, made of whiskey bon-bons, are lined up. The two men begin their match. Each time they take an opponent's piece they eat the bon-bon and, unable to stop themselves, they grow drunker and drunker. The second piece in the film features women at dinner. On the table, wrapped in silver, is the tableware, forks, glasses and plates, which are made of chocolate. They eat the strawberries, bananas, nuts and other food which is served, together with the tableware, as they peel away the silver paper. Both stories feature people who lose themselves to desire. To drink, to gambling, to love and, more than anything else, to the desire to eat sweet things. These two 6 minute short films were our first experience in directing. They were made a success with the help of many people, including actors, video production specialists and chess society members.

R & Y

21_21 DESIGN SIGHT _ short film _ *brown morsels of desire* ⟨2007⟩ R. Uehara & Y. Watanabe

RYUKOTSUSHIN_art performance_*murg tikka lawabadhar "kayojyusu"* 〈2004-2005〉 R. Uehara 青木むすびさん(オブジェ、コメント担当)、辻佐織さん(写真担当)、楠原の3人で、花を愛する南アジア系のアーティスト、ムルグティカラワバドハルというひとりの人間として作品を制作。流行通信で2年間連載をしていました。企画はみんなで考え、楠原は果く塗ったモデルに扮し、スタイリング、フォトディレクションを担当。雑誌の休刊とともに終わってしまいましたが、必要とあれば復活します！ Created by Musubi Aoki (artworks and commentary), Saori Tsuji (photography) and Uehara, all under the fictional guise of a single flower loving South Asian artist named 'Murg Tikka Lawabadhar.' These works were serialized in Ryuko Tsushin magazine over a period of two years. Planning was carried out by all three. Uehara painted himself dark, disguised himself as a model, and was responsible for his own styling and photo direction. The serial ended with the magazine's discontinuation, but if need be it can always be brought back!!

R & Y

9TH MARCH QUINTET (2012) R. Uehara & Y. Watanabe 2012年3月に行われた埼玉県坂戸市立南小学校でのワークショップ。以前、札幌の子どものアートスクール「魔法の絵ふで」で行ったワークショップを進化させたもの。多摩美術大学校友会主催「出前アート大学」の第41回目の企画でした。メンバーは、私たちと作曲家阿部海太郎さん。阿部さんが作曲した五重奏をパラバラに聞かせ、そのイメージを私たちが特別に用意した紙に描いていくという企画。最後に五重奏の生演奏を聴かせるというサプライズ付きでした。

A workshop held in March, 2012 at Minami Elementary School in Sakado City, Saitama Pref. This was a continuation of the "Mahou no Efude (Magic Paintbrush) children's art workshop we had held previously in Sapporo. It was sponsored by the alumni association of Tama Art University as part of their 41st "Delivery Art School". Members included myself and composer Umitaro Abe. For this event, Abe performed a five piece quintet he composed by isolating the parts and we had the students draw what they visualized on paper I had specially prepared. In the end they were also treated to a surprise performance of the reassembled quintet.

R & Y

D-BROS _ stamp, stationary _ *stamp it* ⟨2011⟩

DB in STATION

DB in STATION
STAMP it

STAMP it & DB in STATION

2011年2月25日に品川駅エキュートにオープンしたD-BROS初のオリジナルショップ。限られたスペースで、どんなお店ならお客さんが飽きずに何度も来てもらえるかを考え、ユーザー参加型のプロダクト「STAMP it」が生まれました。「スタンプを押そう。ただひとつのものをつくろう。」というテーマのもと、無地のカードや封筒、ノート等と350種類以上のスタンプを用意し、自由に押していく仕組みをつくりました。植原が"掛け算の棚"と呼ぶこのシステムによって、商品のバリエーションは無限に広がることになります。購入者が自由にスタンプを押せるため、組み合わせやアイディア次第で幾通りでもデザインが生まれ、その人だけのオリジナルのプロダクトを作ることができるのです。私たちとD-BROSのデザインチームによって生み出される「STAMP it」のスタンプは、ひとつでも成立するキャラクター性のあるものから、フレームのように次のスタンプを押したいと思わせるようなものまで、デザイン性はもちろん、そのバリエーションにも気を使っています。白い紙にひとつ目のスタンプを押す緊張感や、イメージとずれた時に変化していく偶然性からも、自分で一点ものプロダクトを生み出す「STAMP it」独特の愉しさを得られるはずです。

STAMP it & DB in station The first original D-BROS shop, opened February 25, 2011 in Shinagawa Station's ecute. The limited space forced us to consider what type of shop customers would return to over and over again without becoming bored. This inspired us to create STAMP it, a product line incorporating user participation. "Let's stamp it. Let's create something unique." Using this theme we provide plain cards, envelopes, notebooks etc. and over 350 different stamps which can be used and mixed freely. This system, which Uehara refers to as "multiplying shelves," allows for an unlimited variation in merchandise. Since the buyer can use the stamps freely the limitless designs are born out of the customer's own combinations and ideas, and they get the chance to make their own original products. Individual design sense is a must, but we also pay careful attention to variation, which is why the STAMP it stamps created by ourselves and the D-BROS design team include everything from character style stamps which appear complete in and of themselves to frame style stamps which make you want to press that next image. The tension as you press the first stamp to white paper and altering your image when it surprises expectations. The peculiar fun of creating a unique product with STAMP it lies in the unpredictability of handcrafted design.

D-BROS _ shop total direction _ *db in station/stamp it* ⟨2011⟩ R.Uehara & Y.Watanabe

D-BROS • HOTEL BUTTERFLY_ 1. wall clock 〈2010〉 2. wine glass & glass holder 〈2011〉 3. year plate 〈2008〉 4. book mark 〈2006〉
5. door plate 〈2006〉 6. flower vase 〈2008〉 7. letter set 〈2009〉 8. cup and saucer 〈2008〉 9. letter paper 〈2006〉 10. year plate 〈2010〉
R.Uehara & Y.Watanabe

R&Y

R & Y

D-BROS・HOTEL BUTTERFLY_sticky memo〈2006〉 R. Uehara & Y. Watanabe 蝶の裏面にメッセージを書き込むメモ付箋。胴体の部分に弱粘の糊が加工されています。まるで蝶がメッセージを運んでくれるような錯覚を呼び起こし、現実と非現実の世界を行き来するホテルバタフライの世界を繋いでくれます。The sticky surface is found on the trunks and messages are written on their reverse side. These sticky notes will create the illusion that a butterfly has come to convey your message, calling forth the world of Hotel Butterfly, a world which flits between fantasy and reality.

Hotel Butterfly A hotel is a miniature society. With necessities and entertainment provided, dramatic tension is also sure to ensue. Indeed, a hotel is perhaps an odd sort of place. We created the Hotel Butterfly line out of a belief that this story of a hotel could be fertile grounds for creating a variety of pieces. The name "Butterfly" was added because, when still, the butterfly appears as a two dimensional graphical representation, but should it flap its wings it bursts forth suddenly in graceful movement. A symbol of creativity, it seemed similar in nature to D-BROS itself. The worldview of Hotel Butterfly begins with the main visual of a single hotel drawing. With this image, we aimed to give each viewer an impression of Hotel Butterfly influenced by their own experiences and recollections. This way, when discovering the actual products, they could enjoy engaging with this conceptualized worldview as they used or viewed them. This exponential relationship between imagination and actual product, where virtual experience becomes possible, is the concept behind Hotel Butterfly. In order to better convey this worldview, the tope page of Hotel Butterfly's website feature a letter of greeting from the hotel's manager. In our in-house presentation, Uehara read a story of his own creation which laid the setting for Hotel Butterfly, while Umitaro Abe produced a song for us based on the hotel. Thus, Hotel Butterfly has already become a story and a song.

PRODUCED BY D-BROS

ホテルバタフライ

ホテルはミニチュアの社会であり、衣食住に遊もあればドラマも生まれる、少々変わった場所でもあります。そんなホテルという場所のストーリーからさまざまなモノが生まれるはずだと考え「ホテルバタフライ」はスタートしました。動きを止めていれば二次元のグラフィカルな存在で、一度羽ばたけば三次元を優雅に泳ぎだす"蝶＝バタフライ"の名を冠したのは、蝶の在り方がD-BROSと近しく、そのクリエイティブの象徴とも思えたからです。ホテルバタフライの世界観は、ホテルが描かれた一枚のメインビジュアルから始まります。この絵には見る人に何かしらのイメージを与え、自分の体験や記憶とつなげてそれぞれのホテルバタフライを想像してもらいたいという狙いがあります。そして実際の商品に出会った時、イメージしていた世界観と掛け合わせながら商品を眺め、使い、楽しむことができるのです。そうしたイメージと現実にあるプロダクトとの掛け算で可能になるバーチャルな体験が、ホテルバタフライのコンセプトです。そうした世界観をより伝えるため、ホテルの支配人からのご挨拶の手紙をウェブサイトのトップに載せました。社内でのプレゼンでは、植原がホテルバタフライの設定を自作の小説のかたちで読み上げ、阿部海太郎さんにはホテルバタフライをイメージした曲もつくってもらいました。ホテルバタフライは小説になることもあれば、音楽になることもあっていいと思います。ホテルバタフライはあらゆる可能性を秘めた世界です。

D-BROS・HOTEL BUTTERFLY_poster 〈2006〉　R.Uehara & Y.Watanabe
D-BROS・HOTEL BUTTERFLY_logomark 〈2006〉　R.Uehara

R

D-BROS _ packing tape _ *a path to the future* ⟨1999⟩　R.Uehara　植原がADとして初めてデザインしたガムテープ。当時こうしたデザインの商品が世の中になく、非常にいい売れ付きを記録。毎日緊張しながら、今までにない商品を探し続けていました。植原最初の東京ADC受賞作。The first packing tape Uehara designed as art director. At the time there were no similar tapes on the market, so sales were excellent. The pressure to search for new products is an everyday phenomenon. This was Uehara's first time winning the Tokyo ADC award.

Y

D-BROS _1.card〈2010〉2.card_ *90°marchen*〈2005〉Y. Watanabe　送る人、送られる人のことを想像しながら数々のカードのデザインをしています。クリスマスのポップアップカードはカラーというとても薄い紙で作りました。ミラーのカードはミラーに白を刷ることで雪景色や水の映り込む世界を表現しました。We've created many cards, always imagining the sender and the sendee as we make them. The Christmas pop-up cards were made out of an extremely thin crepe paper, while the mirror cards were made by printing white patterns in order to invoke a world of snowy landscapes and transitioning water.

BETWEEN 2D AND 3D
BETWEEN REALITY AND FANTASY
BETWEEN UTILITY AND JOYS
BETWEEN RULES AND FREEDOM
BETWEEN WORK AND PLAY
BETWEEN GRAPHICS AND PRODUCTS
THE CONCEPT OF
D-BROS PRODUCTS

D-BROS _ poster _ the concept of d-bros products 〈2006〉 R.Uehara 一度デザインしたものを"解体→再構築"したポスター。自分なりのルールで紙を破り、裏返す。その単純な行為をデザインとしてフィックスさせたもの。D-BROSの商品コンセプトは"between"。このポスターは2次元と3次元の間を行き来するD-BROSの中核にある考え方を表現しています。A poster which disassembles and reconstructs previous designs. Paper was ripped according to our own logic, turned around and, through this simple act, reaffixed as a new design. The central concept of D-BROS is "between". By vacillating between two dimensions and three this poster represents the core thought behind D-BROS.

Between Graphics and Products

D-BROS _ 1.calendar _ *roll12*〈2011〉 2.calendar _ *paper jam white*〈2009〉 3.calendar _ *paper jam*〈2005〉 4.calendar _ *someday, today*〈2008〉
R.Uehara 毎年作っているカレンダーは、紙と印刷などによる質感表現、ある瞬間の時間を表現すること、裏と表の関係によって生まれるデザインを意識して制作しています。D-BROS' yearly calendars are designed with attention to the texture created by paper and printing, to the expression of moments of time, and to the relationship born between front and back.

9

9

		1	2	3	4	
5	6	7	8	9	10	11
12	13	14	15	16	17	18
19	20	21	22	23	24	25
26	27	28	29	30		

D-BROS_calendar_*peace and piece* 〈2003〉 R.Uehara 天糊で製本されていない、形がバラバラ、ひとつひとつオリジナルでコラージュしたかのように見えるカレンダーです。コラージュした状態を表裏まで忠実に再現しました。一見アナログに見えますが、コンピュータとの過酷な闘いでした。N.Y. ADC・GOLDを受賞。 The pages are separate rather than bound by paper, each calendar appearing as its own collage. Faithfully reproduced with advanced printing techniques, including the reverse side. Gold winner, NY ADC prize.

R

D-BROS _ calendar _ *hapen, happy*〈2006〉 R. Uehara 6枚表裏で使用するカレンダー。焦げたカレンダーを作ってみたかったのですが、同時にHotel Butterflyが生まれました。このカレンダーがきっかけとなり、壁にかけると気分が落ち着かず、蝶を止まらせてみたら不思議と空気感が中和されました。A6 page calendar utilizing both front and back. Placing a burnt calendar on your wall makes it surprisingly difficult to relax, but the addition of butterflies neutralizes that miasma. The same butterfly, on the reverse side, returns again six months later.

JANUARY

1 2 3 4 5 6
7 8 9 10 11 12 13
14 15 16 17 18 19 20
21 22 23 24 25 26 27
28 29 30 31

Ribbon

picture and design
yoshie watanabe
2008 D-BROS calendar

D-BROS_calendar_ribbon 〈2007〉 Y.Watanabe　本の栞をリボンにしました。絵のリボンから本物のリボンへ繋がっていく、リボンが旅する物語です。
Ribbons were created from bookmarks, while drawn ribbons blend into real. It is the story of a ribbon which decides to take a journey.

Y

D-BROS_calendar_*sophie* 〈2008〉　Y. Watanabe　お菓子の箱に入っていそうなエンボス加工の紙を3種類作り、エンボスの一部が次々に色づいていくようなデザインにしました。This calendar was designed by creating three different types of paper, with candy box style embossing, and continuing a portion of each embossing onto the next page.

157

Y

D-BROS_calendar_rose 〈2009〉 Y.Watanabe 薄い紙で柔らかくになるポップアップカレンダー。バラの匂いがしてきそうなカレンダーを作りたいと思いました。ONE SHOW DESIGN・GOLDを受賞。 A soft pop-up calendar made from thin paper. The idea was to make a calendar which could almost evoke the scent of roses. Gold winner of One Show Design.

		Sat	Sun	
			1	
5	6	7	8	
12	13	14	15	
18	19	20	21	22
25	26	27	28	29
31				

Y　D-BROS_calendar_*rose* 〈2009〉　Y.Watanabe

January

sunday	1	8	15	22	29
monday	2	9	16	23	30
tuesday	3	10	17	24	31
wednesday	4	11	18	25	
thursday	5	12	19	26	
friday	6	13	20	27	
saturday	7	14	21	28	

January

D-BROS_calendar_*12 letters-windermere*〈2011〉 Y.Watanabe 「12 LETTERS」の2作目。湖水地方に憧れて、イギリスのウィンダミアをイメージした風景や少女、動物を描いています。The second "12 Letters." Captivated by a romantic longing for lakes and shores, the drawings features images of the scenery of Windermere, England, of young girls and of animals.

November

sunday		6	13	20	27
monday		7	14	21	28
tuesday	1	8	15	22	29
wednesday	2	9	16	23	30
thursday	3	10	17	24	
friday	4	11	18	25	
saturday	5	12	19	26	

May

sunday	1	8	15	22	29
monday	2	9	16	23	30
tuesday	3	10	17	24	31
wednesday	4	11	18	25	
thursday	5	12	19	26	
friday	6	13	20	27	
saturday	7	14	21	28	

LETTER IN MAY
DB
March winds and April showers Bring forth May flowers

D-BROS_calendar_12 letters 〈2010〉 Y.Watanabe 毎月大切な誰かに手紙のように送ることのできる封筒付のカレンダー。ピースのブローチをイメージして絵を描きました。東京ADC会員賞、TDC賞、JAGDA賞を受賞。 A calendar with attached envelope, it can be sent every month, like a letter, to that special someone. Winner of the Tokyo ADC Members Award, the TDC Award and the JAGDA award.

28
29
30
31
2/1
2
4
5
6

D-BROS_calendar_*arukuni wo aruku*〈2006〉Y.Watanabe「あるくにをあるく」。少女が森の中をどんどん進んでいき、さまざまなものに出会う旅です。週めくり53枚の物語。"Arukuni wo Aruku (Stroll a Far-off Country)." A girl walks deeper and deeper into the forest, facing a variety of encounters as she goes. A 53 page weekly calendar story.

D-BROS_textile〈2004〉 Y. Watanabe　テキスタイルデザイン。基本的なパターンから色々な花や蝶や蛇を浮かび上がらせました。A textile design. Flowers, birds, snakes and other images were made to float above a standard pattern.

■ R & Y

D-BROS _ paper brooch _ *brooch ever lasting* 〈2005〉 R.Uehara & Y.Watanabe　紙象嵌や箔押しなど紙の加工技術を駆使したブローチです。This D-BROS brooch utilizes inlaid and foil-stamped paper.

METHOD OF DRINKING FAIRY TALE

童話を飲む方法

「ねえ、赤ずきん」狼は言いました。
「森のきれいな花が、まわりじゅうに咲いてるよ。どうして、あたりを眺めてみようとしないんだい。小鳥たちがあんなに可愛く歌ってても、ぜんぜん耳に入らないんだろ。わき目もふらずに歩いて、まるで村の学校に行く時みたいだな。森の中がこんなに楽しいっていうのにさ。」
赤ずきんは目を上げました。見れば、日の光が木のあいだから、ちらちら踊っています。どこを見てもきれいな花でいっぱいです。
赤ずきんは「摘みたての花束を持っていってあげたら、おばあさん、きっと喜ぶわ。まだ早いからあんまりおくれずに着けるでしょう。」と思いました。
そして道からそれて花をさがしに森の中へかけていきました。
そして１本の花を折ると、あそこへ行けばもっときれいなのがあると思って、花を追ってどんどん森の奥深く入りこんでしまいました。

Then he said, "Listen, Little Red Riding Hood, haven't you seen the beautiful flowers that are blossoming in the woods? Why don't you go and take a look? And I don't believe you can hear how beautifully the birds are singing. You are walking along as though you were on your way to school in the village. It is very beautiful in the woods." Little Red Riding Hood opened her eyes and saw the sunlight breaking through the trees and how the ground was covered with beautiful flowers. She thought, "If a take a bouquet to grandmother, she will be very pleased. Anyway, it is still early, and I'll be home on time." And she ran off into the woods looking for flowers. Each time she picked one she thought that she could see an even more beautiful one a little way off, and she ran after it, going further and further into the woods.

D-BROS_glass_*live! together*〈2004〉 R.Uehara　3種類の動物を大きさが2種類のグラスにデザイン。親子のようにみえる大小ペアで販売しました。重ねてディスプレイすると動物たちが戯れているかのように見えます。A glass designed with three different animals, and offered in two sizes. The glasses were sold in a set, for parent and child. If stacked on display, the animals look as if they are frolicking together.

R&Y

D-BROS _ wall clock_ *seconds tick away* 〈2004〉 R.Uehara & Y.Watanabe　全面に模様板ガラスを使用。秒針の形が刻々と変わるため「秒の時計」と名づけました。時はこれくらい曖昧なものです。Features full surface patterned sheet glass. The pattern on the second hand changes from moment to moment, which is why we titled this piece "Seconds Tick Away". Because time is an elusive thing.

D-BROS _ wall clock _ *time paper 'dozen'* 〈2006〉 R. Uehara

<Time paper>　「Time paper」は、これぞD-BROSの時計というものをつくりたいと考えてつくりました。インテリアの中で物の側から情報を発信している代表的なものは、時計とカレンダーです。カレンダーを毎年制作しているなかで、もうひとつの存在である時計の決定版をつくるべきだと思うようになったのです。どんな時計をつくろうかと考えた時、得意のグラフィック表現を活かすことのできるポスターのようなもの、というアイディアが浮かびました。この時計最大の特徴は、紙が四つに折られていることです。十字につけられた折り目が、広げた時に、ムーブメントによる膨らみを目立たなくし、水分の吸水による伸縮とたわみを防止する構造としても機能しています。一見しただけでは気づかない表現と構造が一致したプロダクトになっています。2010年には、ヴィクトリア＆アルバート美術館のミュージアムショップとのコラボレーションで、表裏どちらも使えるオリジナルバージョンを制作しています。

Time Paper　　Time Paper was created when we decided we were ready to design a clock for D-BROS. In interior design, the two main items which transmit information are the clock and the calendar. We were already producing calendars regularly, every year, and decided we should also create that other definitive piece, the clock. When we considered what kind of clock we wanted to produce, it occurred to us that we wanted something which could make strong use of graphic representation, such as a poster. The Time Paper clock's most distinctive feature is that it is folded into four sections. The crosswide folds do an excellent job of handling the bulge of the movement, and also help to protect against any warping cause by water absorption. Initially unassuming, the appearance and construction work together beautifully. In 2010 we created a special version for the Victoria and Albert Museum shop which can be used both front and back.

Mirror Released at the same time as our flower vase, this piece, symbolic of D-BROS own course, plays with flat bodies and three dimensionality. The saucer's pattern is reflected in the mirrored surface of the cup, cup and saucer establishing their design together in a predestined alliance. Before commodification, we experimented repeatedly with the angles of the saucer and cup, and with the product and graphic surfaces, to determine how to produce a two dimensional picture in three dimensions. The white porcelain and extremely hard stone used when creating Nagasaki Hasami pottery allowed us to accentuate the piece's thinness. To produce the pottery, as well as the palladium finished mirroring, we worked with artisans from Tajimi. Since defects unapparent in the unglazed pottery would stand out prominently once coated with mirroring, working with the clay required more care than usually necessary. When the finished piece is picked up the pattern appears to warp and dance, thus the inspiration for the design's name, "Waltz." It is currently on sale together with two other designs, "Rivulets of the Heart" and "From Dawn to Dusk." 2003 was an important year. With the release of both the flower vases and mirror cups the concept behind D-BROS, "between graphics and products," became significantly clearer, determining our future course in the years to come.

▪ R & Y

< Mirror >　フラワーベースと同時期に発売され、平面と立体を行き来する現在のD-BROSの道筋を示した商品のひとつです。ソーサーの柄がミラー加工されたカップの側面に映りこみ、カップ＆ソーサーのデザインが成立するという、二つの運命的な関係を演出したプロダクト。商品化に至るまで、2次元の絵がどう立体的に立ち上がるかを、ソーサーやカップの角度などのプロダクト面とグラフィック面から何度も実験と検証を繰り返しました。白い陶器は、とても硬い石を使うことで薄さを表現できる長崎の波佐見焼の窯元と、表面ミラー部のパラジウム仕上げは多治見の職人とともに作っています。白い生地ではわからない傷もミラーを塗ると目立ってしまうため、白地への気遣いが通常以上に必要になっています。手にとった際、絵柄が歪んで踊っているように見えることから名付けられた「Waltz」をはじめ、「Rivulets of the heart」「From dawn till dusk」の3種類が発売中。フラワーベースと、このミラーカップが発売された2003年は、D-BROSのコンセプトである"Between Graphics and Products"がより明確化され、これ以後の方向性を決定づける大きな年となりました。

D-BROS_1.cup and saucer_*mirror 'from dawn till dusk'*〈2008〉 2.cup and saucer_*mirror 'rivulets of the heart'*〈2003〉　　R.Uehara & Y.Watanabe

137

<*Hope forever blossoming*> 　私たちの代表作であり、今やD-BROSの名刺代わりとも言える「hope forever blossoming」。2002年のある日、植原がシャンプーの詰め替え用パッケージのデザインをしている時、このフラワーベースは生まれました。円筒状のビニール容器に水を入れてラベルのデザインを検証していましたが、その日は思うように進まず途中で帰宅。翌日、会社に来てみると、そこに一輪の花が挿してありました。それを見た植原は、渡邉に「これ、商品にできるよ」と駆け寄ると、「それ、私が挿したの」と渡邉。無意識のうちに庭に咲いていた花を挿したのです。そんなエピソードを持つ発想の瞬間は、宮田さんのつくり出した環境と教えが生み出したとも言えます。宮田さんは常日頃、「庭を観察しなさい。デザインのヒントが隠れている」と、社員教育の一環としてそう促していました。椿をモチーフにした渡邉の時計を始め、庭をきっかけに生み出されたクリエイションはいくつもあります。このフラワーベースの重要なポイントは、筒状のまま終わらないこと、そしてビニールのアウトラインが四角いままであることです。それは、持ち手としての機能や製造工程を省けることだけでなく、シャンプーの詰め替え用パッケージであった痕跡を残すこと、また、ミニマムで単純な四角形から生まれるクリエイションであることのデザイン的な意味を示唆してくれるからなのです。薄さ、軽さ、安さという輸出に有利な条件を備えたフラワーベースは、グッゲンハイム美術館やフランスの人気セレクトショップmerciなど、世界の主要都市で販売されています。発売から10年経過した今も毎年新作を追加し、2012年現在、10シリーズ約60種類のデザインが各地の店頭に並んでいます。

Hope forever blossoming　Our representative work, "hope forever blossoming" can almost be thought of as the calling card of D-BROS. This vase was created one day in 2002, when Uehara was busily working on the design for a refillable shampoo package. After filling the package with water he struggled to create a label design, but the work proceeded much less smoothly than he had hoped and he returned home before it was finished. When he returned to work the next day a single flower had been placed into the container. When Uehara saw it he rushed over to Watanabe and shouted, "we can make this a product!" To which Watanabe replied, "I put that flower there." Without giving it any special thought, Watanabe had placed a flower which was blooming in the company garden into the package. Of course, it could even be said that that moment of inspiration owed something to the environment which Miyata had created. When mentoring his employees, Miyata would regularly tell them to "look into the garden! Design hints lie waiting there." More than one creation, such as Watanabe's camellia motif clock, was inspired by that garden. An important point to the vase is that despite its being cylindrical the vinyl frame is actually rectangular. Not only does this make it easier to carry and simplify manufacturing, but leaving traces of the original refillable shampoo package also has design value by suggesting the piece's origins as a simple minimalist rectangle. Thin, light and inexpensive, the vase is perfectly suited for export, and is sold at major cities throughout the world in places such as the Guggenheim Museum or France's popular select shop, Merci. 10 years since launch and we are still adding new pieces. As of 2012 10 series, and over 60 designs, can be found in shops throughout the world.

R & Y

ディーブロス

私たちが15年近く手掛けてきたプロダクトデザインの仕事。二人が最も力を入れてきた仕事のひとつです。D-BROSは、1995年にDRAFTの代表兼D-BROSのCDでもある宮田識さんが、デザイン事務所自らがメーカーとなって、制作、宣伝、卸し、販売までを一貫して行なうブランドとして立ち上げました。D-BROSの営業戦略の中心的存在であったプロデューサーの中岡美奈子さんは、D-BROSにとって未知の"メーカー"という領域を、設立時から開拓してくれました。宮田さんがD-BROSを立ち上げたのはいくつかの理由（社員の表現の場をつくること、グラフィックデザイナーの新しいフィールドづくり等）があります。中でも一番の理由は、普段の仕事において丁寧に企業やブランドのイメージを育ててきたにもかかわらず、広報担当者が入れ替わることで方針転換が簡単に起こり、しばしば意図せず中途で手を離れてしまうことでした。それならば自分たちですべてをコントロールできるブランドを作ってみようとなったわけです。発足から1年、D-BROSの専属デザイナーになることを言われた渡邉は、プロダクトという未知のジャンルに抵抗感があったものの、社内のカレンダーコンペで選ばれた作品がADC賞を受賞し、紙のプロダクトの可能性を感じるようになりました。1999年には、渡邉とのキャスロンの仕事をきっかけに植原が参加。D-BROSとして初めてデザインしたガムテープでADC賞を受賞しました。それ以後、様々な紙製品からテーブルウェア、時計、テキスタイル製品など、それまでグラフィックデザイナーの領域ではないと思われていたジャンルのデザインをたくさん手掛け、D-BROSのデザインをリードしてきました。2003年、シャンプーの詰め替え用パッケージの仕組みを応用しデザインされたフラワーベース「hope forever blossoming」は、日本だけではなく、海外主要都市のミュージアムショップやセレクトショップなどで販売され、現在までに40万袋以上が売られています。平面と立体の中間にあるフラワーベースやミラー仕上げのカップ＆ソーサーなどがそうであるように、D-BROSのものづくりのコンセプトは"間"を意味する"between"です。2D＆3D、ユーティリティ＆トイ、リアリティ＆ファンタジー、ルール＆フリーダム、グラフィック＆プロダクトなど、2つの「間」を回遊することをデザインの軸にしながら、ジャンルに縛られない自由なものづくりを目指しています。私たちはDRAFTからキギに移り、以前より俯瞰した立場での関わりとなります。ますますDRAFTの若いデザイナーたちに多くのチャンスがあるでしょう。これからも皆でD-BROSという木にきちんと栄養と水を与えながら、しっかりと根の張った大きな存在にしていきたいと思っています。

D-BROS We have worked on D-BROS product design now for nearly 15 years, and it is undoubtedly the project containing the most of our combined blood, sweat and tears. D-BROS was started in 1995 when, transitioning from design company into a manufacturing brand, DRAFT Co., Ltd.'s representative designer (as well as the creative director of D-BROS), Satoru Miyata, solidified creation, advertisement, wholesale and retail. At the heart of D-BROS' sales strategy was producer Minako Nakaoka, who from inception worked hard to develop, what was for D-BROS, the still unknown field of "manufacturing." Miyata had several reasons for wanting to create D-BROS (to create a place for firm members to express themselves, to create a new field for graphic designers, etc.). But foremost among these reasons was that in the regular course of course of work, despite carefully fostering a business and brand image, once the person in charge of PR changes, plans and objectives would frequently change as well. Often work would be abandoned partway through, without achieving the original aims. This was the impetus behind wanting to create a brand where the control lied entirely with ourselves. Watanabe, who was made an exclusive designer at D-BROS, initially felt reluctance at venturing into the new field of product design. Despite this, a year after the company's inauguration, a piece chosen by an in-house calendar competition received the Tokyo Art Directors Club (ADC) award and Watanabe began to see the possibilities inherent in paper products. Uehara joined in 1999 after working with Watanabe on the Caslon project. The first packing tape he designed also received the ADC award. Thereafter, we took the lead in design at D-BROS, trying our hand at a variety of paper products as well as at tableware, clocks, textile products and a wealth of other items usually considered outside the field of graphic design. In 2003 our flower vase, "hope forever blossoming," which was designed using the same construction as refillable shampoo packaging, was sold widely not only in Japan but in select shops and museum stores worldwide. Over 400,000 have sold to date. With products such as this flower vase, which rests somewhere between flat surface and three dimensional object, or our mirror finished cup and saucer, "between" grew to be the unifying concept behind D-BROS manufacturing. 2D and 3D. Utility and toy. Reality and fantasy. Freedom and rule. Graphic and product. As we tread the axis between concepts, our goal is to manufacture freely, unbound by genre. Since moving from DRAFT to KIGI we've been able to view production from a higher position that ever before. I'm sure more and more chances lie in wait for the young designers at DRAFT. As we continue to water the tree which is D-BROS together, I hope that the routes grow strong and it remains a strong presence for all of us.

D-BROS_logomark 〈2002〉 R.Uehara
D-BROS_flower vase_*hope forever blossoming* 〈2003〉 R.Uehara & Y.Watanabe 東京ADC賞を受賞しました。Winner of the ADC Award.

DDB

SOEN_art works for magazine 〈2007〉 Y. Watanabe 雑誌「装苑」で、スタイリスト大森伃佑子さんとのコラボレーションで、白いシャツ、白い花瓶、白い額、白い本にフリルや本のタイトル、花瓶の柄などを映写しました。カメラマンは土井文雄さん。Collaboration with Soen magazine stylist Yoko Omori. Onto the white shirts, white vases, white faces and white books we projected frills, the vase's pattern, etc. Camera work by Fumio Doi.

LAFORET HARAJUKU poster *decoration, laforet* 〈2005〉 R.Uehara 青木むすびさんと一緒に制作したラフォーレ原宿の年間広告ポスター。人間ケーキは実際に直径3メートルのケーキのステージを作り、撮影しました。写真は辻佐織さん、スタイリングは飯嶋久美子さん、メイクは神崎美香さん、イラストのポスターがワルシャワポスタービエンナーレ・SILVERを受賞。Annual poster for Laforet HARAJUKU, created together with Musub Aoki. The human cake we actually photographed on a 3m wide cake stage. Made in collaboration with photographer Saori Tsuji, stylist Kumiko Iijima and makeup artist Mika Kanzaki. This illustrated poster won silver place at the Warsaw International Poster Biennale.

Decoration.
LAFORET

TOKYO ART DIRECTORS CLUB _poster, book 〈2009〉 R. Uehara

2009 ADC展

2009 Tokyo Art Directors Club Exhibition

ADC

PANASONIC＿catalogue,dm＿*i-x*〈2007〉 R.Uehara プロダクトデザイナー深澤直人さんが設計、デザインしたユニットバスのカタログとDM。BtoB用の営業ツールとして使用するためのものでした。Catalogue and direct mailings for designer unit bath fixtures which were planned by product designer Naoto Fukasawa. The BtoB business tools.

Y

SOFINA BEAUTÉ_package 〈2011〉 Y. Watanabe　ソフィーナボーテのパッケージ。ドラフトの宮田識さんと一緒にデザインしました。量産品でありながら、手作り感のあるものを目指しました。Packaging for SOFINA beauté, designed together with DRAFT's Satoru Miyata. The aim was to create a hand-made feel.

SEMPRE_ogomark,shopping bag,gift box〈2007〉 R.Uehara インテリアショップSEMPREのロゴマーク及びグラフィックの仕事は、初めてADとしてクライアントにプレゼンをした仕事。当時27歳で社会人3年目、前日に猛練習をしたにもかかわらず緊張のあまり忘れ、その場で資料を読み上げてしまいました。Logo mark and graphic for SEMPRE interior shop. This was Uehara's first presentation to ε client as an art director. "I was 27 and I had only been working for three years. I practiced the day before but I forgot everything and had to read off of my paper."

R

Tokyo's Tokyo

TOKYO'S TOKYO _ logomark,shop,tool 〈2009〉 R.Uehara. 羽田空港にある東京のお土産ショップ「トーキョーズトーキョー」。BACHのブックディレクター幅允孝さんがプロデュースしたお店で、ロゴマーク、ショッピングバッグ、Tシャツなどのグラフィックを担当しました。Tokyo's Tokyo is a Tokyo souvenir shop in Haneda airport. Produced by BACH's book director, Yoshitaka Haba. We handled graphics for the logo, shopping bags, t-shirts and more.

R & Y

SPIRAL RENDEZ-VOUS PROJECT _ sandals _ *peanutti* 〈2008〉 R. Uehara & Y. Watanabe　スパイラルが取り組む「静岡ランデブープロジェクト」で誕生したピーナッチは、ダイマツとのコラボレーション商品。先の尖ったピーナッツ型で、表面も殻のデコボコもリアルに表現。殻のように人の足をやさしく包みこみたいという思いも込められています。The spiraled Peanutti, created for Shizuoka Rendez-vous Project, was produced in collaboration with Daimatsu. The realistic peanut design tapers to a point and features an uneven, shell-like surface. Like a shell, it is meant to gently cradle a person's foot as they walk.

R & Y

SENZ°_umbrella textile_*umbrella for the earth*〈2010〉R.Uehara & Y.Watanabe　オランダの傘メーカー、センズ社の傘のテキスタイル。水の惑星と雨の恵みをテーマにデザインしました。A textile created for Senz, an umbrella manufacturer from the Netherlands. Designed with the themes of a watery planet and the rain's blessing.

HAAT_ illustration for textile〈2007〉Y.Watanabe　ファッションブランドHaaTのディレクター皆川魔鬼子さんからTシャツのためのイラストを依頼されました。その他ソックス、ストールなどになりました。
A t-shirt illustration requested by HaaT director Makiko Minagawa. Also used on socks, stoles, etc.

R & Y

COCCA_textile_*lily* (2009)　R. Uehara & Y. Watanabe　ファブリックブランド・コッカとのコラボレーションで作ったテキスタイル。シャツ、スカート、ワンピース、傘などいろいろなものに変わりました。百合の群生、水滴をイメージしています。A textile created in collaboration with fabric brand, COCCA, it has been used in a variety of items, such as shirts, skirts, dresses and umbrellas. Created with a theme of crowded lilies and raindrops.

Y

SHISEIDO_note book_*word*〈2006〉Y.Watanabe　資生堂カルチャープログラム終了時の記念ノート。デザインプロデューサーは秋山道男さん。ノートの緑と青の線が草や波に変わっていき、また線に戻っていきます。A notebook commemorating the close of Shiseido's culture program. Design produced by Michio Akiyama. The green and blue stripes of the notebook become grass and waves, then return to stripes again.

R & Y

kôk_wrapping paper_nest〈2007〉R. Uehara & Y. Watanabe
ネットショップ、ネストの包装紙。巣を意味する店名から、鳥の巣をイメージしたデザインです。Wrapping paper for online shop, Nest. The bird's nest theme was used in order to match the store's name.

R & Y

[日] MAI_cd jacket_miki's affections《2011》 R. Uehara & Y. Watanabe 今井美樹さんのデビュー25周年の記念アルバム。渡邊による花のイラスト、若木信吾さんによる空と海の写真をつかって、植原がデザインしました。 A commemorative album celebrating the 25th anniversary of Miki Imai's debut. Uehara handled art direction, incorporating flower illustrations by Watanabe as well as photographs of coastal skies by Shingo Wakagi.

[日] TOTO_cd jacket_key《2008》 R. Uehara & Y. Watanabe 植原がアートディレクション、渡邊がイラストを担当した一青窈さんのベストアルバム『KEY』。パッケージの全体に渡邊の描くイラストがエンボスされていて、レインボーの色鉛筆で擦った絵が浮き出ている(フロッタージュ)ようなデザインにしました。 Yo Hitoto's 'best of' album, Key. Uehara handled art direction while Watanabe was responsible for illustrations. Designed so that the pictures appear to float upwards, the entire packaging is embossed with Watanabe's illustrations and then frottaged with colored pencil.

SWITCH PUBLISHING_book_*harajuku hyakkei* 〈2010〉 R.Uehara 小泉今日子さんが雑誌『SWITCH』で「原宿百景」というタイトルで連載をしているものをまとめた本です。エッセイと対談と写真で原宿を紹介しています。写真は若木信吾さん。"Harajuku Hyakkei" (100 Views of Harajuku) is a collection of pieces serialized by singer/actress Kyoko Koizumi in the magazine, SWITCH. It introduces the neighborhood of Harajuku through essay, dialogue and photography. Photographs by Shingo Wakagi.

TAEKO ONUKI_cd jacket_*boucles d'oreilles* 〈2007〉 Y.Watanabe 大貫妙子さんのCDジャケット。ゆらゆら揺れるイヤリングという意味のタイトルや大貫さんの透明な歌声をイメージしています。 A CD jacket for Taeko Onuki. Inspired by the title, which means 'a dangling earring', as well as by Onuki's own clear voice.

植原亮輔さんと渡邉良重さんとの仕事　　阿部海太郎（作曲家）

僕にとって人生で初めての作曲の仕事が、植原亮輔さんと渡邉良重さんとの仕事でした。それはD-BROSで「ホテルバタフライ」が新しくつくられた際、その架空のホテルを開業した時のBGMをつくるというもので、人々の数々の仕事の話よりぐちゃめちゃありました。第一線で活躍する二人が、当時学生を終えたばかりの僕の音楽を良いと思ってくれたのには驚いたし、声をかけてもらったときの嬉しさと、二人のデザインを通して社会に向けて作曲する喜びを感じたことは、一生忘れられません。さて、その後も映像作品「欲望の茶色い塊」や、広告の中の渡邉良重さんの「ソフィーナボーテ」、植原さんの「gredecana」など、様々な機会でご一緒することになりましたが、植原さんや良重さんとの仕事は自分にとって常に特別な意味も持っています。というのは、ほとんどの場合、音楽の内容に関して僕に任せてもらうことが多いからです。音楽制作の仕事においてこのような関係はとても稀で、一般的には演出家もしくはディレクターという他者と対峙しながら、お互いに未だ見ぬ世界に向かって、いかにして作品を仕上げていくかが問われます。演出家とのこの「対峙」にも、もちろん大きな意義があります。しかし、植原さんや良重さんとの仕事の場合は、もちろんディレクターと作曲家の関係はありますが、より大きく任されるので責任は重く、結果として自分とのたたかいになります。言い換えれば、自分にとっての理想の何たるかが問われ、自分の想像力の限界はどこにあるかが、直接的に問われるのです。表現者にとって過酷な状況ですが、しかし僕は二人との創作の中で冒険を恐れないし、最も美しい表現を目指すための努力ができます。なぜなら、二人のことを心から信じ、愛するからです。二人が作る「手触り」とも呼ぶべきものには、今日の表現のあるべき姿──審美主義と消費主義の両方から見事に逃れた表現が実現していると僕は思っています。簡単に手に入るから簡単に手放してしまう現代において、二人の生みだす「手触り」は、生身のリアルな経験を呼び起こします。この尊敬すべき仕事を、そして、植原さんという人や良重さんという人を、僕は信じ、愛さずにはいられません。植原さんと良重さんと一緒に未だ見ぬ表現を目指す仕事を続けられることは、僕の作曲家人生をきっと僕自身の想像以上に、幸せなものにしてくれているのです。

Working with Ryosuke Uehara and Yoshie Watanabe　　　　　　　　　　　　　　　　　　　　　　　　　　　　　　　　　Umitaro Abe/Composer

My first job composing, ever, was with Ryosuke Uehara and Yoshie Watanabe. They were launching their D-BROS' "Hotel Butterfly" line, and I was to be responsible for composing the background music for this fictitious hotel. It was the first of many projects I did with them. But no matter how long I live, I will never forget my surprise that these two, who were out there working on the forefront, would find something to like in the music by someone like me who had just finished school, or how glad I felt when they approached me, or the happiness I felt getting a chance to compose music for society through the medium of their design. I soon had many such opportunities to work with them, as with their film "Brown Morsels of Desire" (Yokubo no Chaiiroi Katamari), Watanabe's ad work with "SOFINA beauté," or on "gredecana" with Uehara. But for me, the work I do with Uehara and Watanabe holds special meaning. Part of the reason behind this is that, in most cases, they leave the content of the music up to me to decide. When doing composing work this sort of relationship is very rare. Usually you have to face off against the director over the unrealized piece to decide how and in what way it gets made. This sort of interaction with the director is very significant in its own way. But with Uehara and Watanabe, even though the relationship is one of director and composer, because they leave so much more to my judgment the responsibility is greater and I have to face off against myself instead.To put it in other words, I have to ask myself much more directly what the point of my ideals is, and where the limit to my imagination lies. For a creative person this may sound like a difficult circumstance to work under, but within the framework of their creativity I am not afraid to take new risks, and to work hard in order to find the most beautiful way of expressing the work as I can. This is because I believe in Uehara and Watanabe, and love them from the bottom of my heart. I am convinced that the 'texture' that these two create when they work is the ideal form for expression in the present, a form which I believe makes a heroic escape from both aestheticism and consumerism. In our modern age, where it is easy to get a thing and thus easy to give it up, the 'texture' which the two create recalls real living experience. What these two do is truly inspiring. It is impossible for me not to believe in them, for me not to love them. I know that the opportunity to continue working with Uehara and Watanabe, as we search for new forms of expression, is sure to bring more happiness to my creative and musical life than I could ever imagine.

■ R
■ R & Y

THEATRE MUSICA _ cd jacket _ *soundtrack for d-bros* 〈2008〉 R.Uehara & Y.Watanabe
UMITARO ABE _ 1.name card 2.logomark 〈2011〉 R.Uehara

THEATRE MUSICA_poster 〈2011〉 R.Uehara

「2台のピアノによる演奏会」Vol.3　THEATRE MUSICA presents
011. 4.29 FRI.　START 19:00 OPEN 18:30　前売 ¥3,500　当日 ¥4,000
ウヤマタケオ　阿部海太郎　at jiyugakuen myounichikan　自由学園明日館

Fashion

graphic

FASHION / GRAPHIC
Ryosuke Uehara・Atsuki Kikuchi・Naomi Hirabayashi

2008 9.29 MON – 10.24 FRI 11:00 AM – 7:00 PM 【WED 11:00 AM – 8:30 PM】
CLOSED: SATURDAYS, SUNDAYS AND NATIONAL HOLIDAYS ADMISSION: FREE

MIHARAYASUHIRO _ 1.invitation _ *2002 s/s pop ironies* 〈2001〉 2.envelope 〈2003〉 R.Uehara

MIHARAYASUHIRO_invitation_2002 a/w pop ironies〈2002〉 R.Uehara　大学時代からの友人であるファッションデザイナー三原康裕さんのブランド「MIHARAYASUHIRO」の仕事。2001年から櫃原が担当しました。2002年のインビテーションで、東京ADC賞、豪YOUNG GUN GOLDを受賞しました。 Work done for designer Mihara Yasuhiro's 'MIHARAYASUHIRO' line. Yasuhiro has been a friend since college and Uehara has handled this project since 2001. Invited to participate, this work was selected to receive the Tokyo ADC award and in the Australian Young Gun awards GOLD.

POP IRONIES
NOTHING IS
GOOD OR EVIL.

MIHARAYASUHIRO

GRAPHIC TRIAL 2009 - Repetition on Surface

"Graphic Trial" is an experiment in which I pursue the rerationship between graphic des and printing expression in depth in order to acquire new expressions.

GRAPHIC TRIAL 2009 - Repetition on Surface

"Graphic Trial" is an experiment in which I pursue the rerationship between graphic design and printing expression in depth in order to acquire new expressions.

GRAPHIC TRIAL 2009 Design by Kyosuke Ichihara Printing Direction by Jun Nakayama Produced and Printed by Toppan Printing Co., Ltd.

R

TOPPAN PRINTING_poster_*repetition on surface* 〈2009〉 R. Uehara 凸版印刷の企画展「グラフィックトライアル」で制作したポスター。任意のパターンを作成し、その色塗りによって人を描いています。フランスの古い写真館の写真を現代の感覚で表現し直したもの。薄い包装用紙、透明ニス、銀等による質感の違いが表現の微妙なレイヤーになるように設計しました。N.Y. ADC・SILVERを受賞。A poster created at the letterpress exhibition, "Graphic Trial." A random pattern is applied to it to create a person, remaking photographs from an old French studio in a modern sensibility. Materials with unusual texture such as thin wrapping paper, transparent varnish or silver add a layer of subtlety. The poster received silver prize at the N.Y. ADC.

GRAPHIC TRIAL 2009 - Repetition on Surface

"Graphic Trial" is an experiment in which I pursue the rerationship between graphic design and printing expression in depth in order to acquire new expressions.

PRIVATE WORKS_sticker poster, *implosion↔explosion* ⟨2012⟩ R.Uehara これは小さな丸いシールの集合で出来ています。このシールを剥がして使うことで絵が壊れていきます。剥がされた様々なモノに貼られミシール に、価値を変えて人々の生活に拡がっていきます。This piece is composed out of small round stickers which can be peeled offand used, deconstructing the image in the process. Applied elsewhere, the stickers gain new value by disseminating into daily life.

MAMA! MILK _ cd jacket _ fragrance of notes 〈2007〉 R. Uehara　アコーディオン(生駒祐子)とコントラバス(清水恒輔)による音楽家ユニットmama!milkのアルバムジャケット。アルバムのタイトルテーマに、字を書くというよりも、絵を描くような気分でデザインしました。Album jacket for accordion (Yuko Ikoma) and contrabass (Kosuke Shimizu) unit, mama!milk. The jacket was designed so that its typography would seem more like drawn pictures than written letters.

A rosa moschata
 avant fermentation •
 antique gold
 pale anise
 anise
 intermezzo, op.32
 kujaku
 hourglass
 mano seca

B rosa mundi
 smoky dawn ••
 the moon
 two ripples
 sometime sweet •
 waltz, waltz

Fragrance of Notes
mama!milk

produced by mama!milk
compositions written by Yuko Ikoma (except •)
by Kosuke Shimizu (•)

mama!milk
Yuko Ikoma : accordion
Kosuke Shimizu : contrabass

additional musicians
Gak Sato : theremin
Waichi Iseburi : flute, trombone
Takuo Toyama : piano
Tatsuo Kuribara : drums

recorded from August 2007 to April 2008
recording engineer : Oni Hayashi (except ••)
assistant engineer : Hiroshi Nakata, Kota Tanaka
recorded at Osaka Geidiuts Suzuokan,
Osaka, Japan (except •)
recorded at Cafe Dots, Osaka, Japan (•)
recorded at Kosuke Shimizu at Art complex 1928,
Kyoto, Japan (••)

mixed & mastered by Oni Hayashi
at Shiotra Audio for Living

art direction & design : Ryosuke Uehara
design : Aya Ito

28? Kazuki Tamura

Fragrance of Notes
mama!milk

Y MAYONAKA_ _illustration_ for magazine_ *choucho* ⟨2011⟩ Y Watanabe 雑誌「真夜中」の"物語とデザイン"という特集で、詩人まどみちおさんの詩「チョウチョウ」に絵をつけた中の2ページです。Two pages of illustration cr Michio Mado's poem, "Chou-Chou" (Butterfly) in the special "Story and Design" issue of Mayonaka magazine.

6

THEATRE PRODUCTS _ invitation, poster _ *2008 a/w cyndi* 〈2008〉 R.Uehara

小さな劇場の舞台で　　　　　　　　　　　　　　　　　　　　　服部一成（グラフィックデザイナー／アートディレクター）

渡邉良重さんの絵は、描かれた登場人物や小道具や風景の、どの部分からでもすぐに物語が始まりそうで、見るたび、知らずに誘い込まれている。遠近法以前の絵画のような、陰影のない、平面的で抑揚を欠いた描写である。それが平たい紙の上に印刷されている。しかし印象は立体的だ。独特の臨場感がある。小さな舞台を客席の後ろのカーテンの隙間から覗き見ている、そんな感覚と言えるかもしれない。舞台の上では少女が、口を閉じて立っている。奇妙に醒めた目だ。秘密をひとり見ていた、そんな目に思える。今になにか台詞を語り出すかもしれないと、こちらは耳をすませる。ところが、この舞台は終始、無音である。どんなに大きく紙一杯に描かれていても、どんなに大きく口を開いても、この少女は声を出さない。馬が走っても、足音はしない。渡邉さんの絵の登場人物はみな、どこか不自由そうなのだ。鳥が空を舞うように描かれていても、籠の中に捕らえられた鳥の寂しさが微妙に漂う。少女は話せない。馬は走れない。雨粒は空中で止まったままだ。一抹の寂しさ。塗られた色が華やかであっても、この感触は消えない。これは渡邉さんの絵に宿命的なことに違いない、と作者をつかまえたつもりになった時、こちらも渡邉さんの術中に捕らえられている。寂しさに心惹かれてしまっている。少女・馬・白鳥・草花・果実・森・湖、道具立ては童話の世界を思わせる。でもこの物語には、言葉による筋書きはない。言葉の代わりに物語を進めるのは、デザイン上の工夫、構図や素材や構造上の仕掛けだ。うすい紙に透ける絵の重なり、紙の表と裏をつなぐ糸、切り抜かれたかたちとかたち。この小さな劇場の舞台装置が、巧みな場面転換で、登場人物たちを物語の先へ先へと進めていく。小さかったはずの舞台は、いつのまにか果てしなく広がっている。どこまでいってもこの物語には結末がない。僕は気まぐれに絵のどの部分からでも物語に入って、束の間、抽象的な物語世界をたどり、どこからでも現実の日常に戻ることができる。白日夢に似たこの体験を、この先どれくらい味わうだろう。

Atop a Small Stage　　　　　　　　　　　　　　　　　　　　　*Hattori Kazunari/Graphic designer and Art director*

Every element in Yoshie Watanabe's picture, whether it be the characters, the inanimate objects or the scenery, seems ready to tell a story, drawing the reader in, unawares, to its narrative. Similar to paintings down before perspective drawing, her works lack shadow and planar modulation. Additionally, they are printed upon flat paper. Nevertheless, they still give an impression of three dimensionality. They are possessed of a peculiar presence, an impression perhaps akin to peering in upon a small stage from the gaps in a curtain at the theatre's rear.

Atop the stage stands a young girl with her mouth closed. Her eyes are strangely lucid, as if privy to their own secret. The audience bends its ear close, expecting any moment for her to utter her lines. But this play is one performed entirely in silence. No matter how large the piece of paper upon which this girl is drawn spreads, no matter how wide she should open her mouth, the girl will not speak. Were a horse to run across the stage, its hooves would run in silence. Thus, it seems, the characters which appear in Watanabe's pictures all wield some disability. Even should Watanabe draw us a flying horse there is a sadness to that horse, as if rather than be flying through the sky it is trapped in a cage. The girl cannot speak. The horse cannot run. Raindrops stand suspended in air, unable to fall. Each of Watanabe's pieces is tinged with melancholy. Even when the colors involved are vibrant this melancholy remains. And just when we think we have found the inevitable in Watanabe's works, and have come to grips with her as an artist, we found that we have been at her mercy all along. For it is this melancholy loneliness which draws us to her.

Young girls, horses, swans, flower, fruits, forests and lakes—the subjects she uses are from a world of fairy tales. However, the stories they tell bear no outline made of words. Instead the labor of design, composition, materials and structure advance this story in place of words: images lying transposed up tissue paper, a thread joining the front and back of a single page, forms and extracted forms. A skilful hand changes the scene, ushering the players upon the stage toward the next destination in their story. And so, somewhere along the line, this stage, which we thought had been so small, now spreads out to infinity.

It is a story which continues on indefinitely. We are free to approach her works from whichever angle we choose and be quickly drawn into an abstract world of fairy tales, then free again to return to everyday realism from whichever path we choose. Much like a daydream. How many of Watanabe's dreams still lie in store for us, only the future will tell.

GONTITI_illustration for cd jacket, *humble music* 〈2011〉 Y.Watanabe 「夕暮れの入口」「船乗りとタコの友情」「夜のバラ園」「僕は帰ろう」など、歌のタイトルとゴンチチさんをイメージして絵を描きました。"The Entrance to Evening," "The Friendship of the Sailor and the Octopus," "Nighttime Rose Garden," "I'm Going Home"…These pictures were drawn to represent GONTITI and the titles of their songs.

Y

D-BROS_illustrations for calendar_ *12 letters* ⟨2011⟩ Y.Watanabe

ACCENTUAL_gift package〈2003〉 **Y.Watanabe** アクセサリーのギフトボックス。箱そのものがギフトになるようにデザインしました。内側に施されたミラー加工により箱の中の世界が広がります。小さなものも固定できるように、紐を通す穴を開けています。A gift box for Accentual. The box was designed so that it could appear, itself, to be a gift. Due to the mirror coating inside, the world inside the box seems vast and wide. Features a hole allowing smaller objects to be secured with string.

CHICHU ART MUSEUM, notebook 〈2006〉 Y.Watanabe 香川県直島の地中美術館のミュージアムショップのためのノート。直島の風景を描いています。A notebook designed for the museum shop in Chichu Art Museum, Naoshima, Kagawa Pref. Features drawings of Naoshima scenery.

ETSUKO SONOBE _ jewelry package 〈2011〉 Y. Watanabe　アクセサリーのパッケージ。薗部悦子さんのグラフィカルで大胆なデザインに似合うこと、サイズの異なるものをしっかり固定できること。この2点を考慮して、ハニカム構造を利用した仕組みを考えました。Packaging for accessories. In order to suit Etsuko Sonobe's bold and graphical design, and to firmly hold items of different sizes, the packaging was devised on a honeycomb pattern.

...n it went
...melting down
to the earth

picture & design by yuko watanabe　lyric from "liquid" by ryoko ackida　music by ugh beat　photograph by tamotsu fujii

...it went melting down to the earth　　Have you witnessed the moment of rebirth?

mirror mirror on the wall wallpaper paper doll doll house house of love love of spouse spouse and mouse mouse named tricky tricky is a hippie hippie

one wish you want

doubt without

...e thing is for sure, you're not here to be burned down. Now I see you dried up
...I turned into ash. Does the rain know that it can't wash away this reality?
...we all know that we could change reality right here? End of the night, you
...ow from underground, searching for the light, daylight.

HINISM _ art works for magazine 〈2005〉 Y. Watanabe 雑誌「ヒニスム」での連載。4回シリーズ、6ページのアートワークで、写真は藤井保さんに撮っていただきました。夢の中の花畑をイメージしています。A serial in the magazine, 'hinism,' featuring four installations with six pages of art. Photographs were taken by Tamotsu Fuji. The work depicts a flower garden of dreams.

End of the night, you grow from underground, searching for the light, You've waited slowly for this moment. Break through the earth covering to feel the new world. Spread out branches, strong and long, reach out to wind. Thousand leaves may spring to life, sing and dance with all those

PRIVATE WORKS_picture book, *buch*〈2001〉 Y. Watanabe 展覧会のために作った本。言葉は笠原千晶さんに書いていただきました。指輪のパッケージの元になりました。N.Y. ADC・GOLDを受賞。 ションヒビド for ョー ョhibition. Words by Chiaki Kasahara. This book was the basis for a ring packaging design. Gold winner of N.Y. ADC.

CROSSING

Y

PROPONERE_ ring package〈2005〉Y. Watanabe 婚約指輪のパッケージ。本のページをくり抜いて窓を作り、その窓越しの部屋の物語を考えてデザインしました。冒頭には結婚にまつわる詩を内田也哉子さんに書いていただきました。フェルトを使い、指輪が落ちない仕組みも開発しました。D&AD・イエローペンシルを受賞。Engagement ring packaging. It was designed by imagining the window created by turning through the pages of a book, and the story taking place through that window, with a poem Yayako Uchida regarding a wedding placed in the beginning. A system using felt was developed to prevent the ring from falling out. Winner of the D&AD Award Yellow Pencil.

UN DEUX

Y

DEUX ドゥ

誰かとおなじ自分など いないって　　　　　　　　　　　歩いてゆきましょう

LITTLE MORE _ picture book _ *un deux* 〈2008〉　Y. Watanabe　D-BROSのカレンダー「UN DEUX」から生まれた絵本。文は高山なおみさん。左右のページを交互にめくって物語が展開していきます。A picture book inspired by D-BROS' "UN DEUX" calendar, which was designed by Watanabe. Words by Naomi Takayama. The story unfolds by following the pages alternately left and right.

「わたしの絵に、言葉をつけてください。」　　　　　　　　　　　　　　　　　　　　　　　　　　内田也哉子（文筆家／sighboat）

ある日、ぎこちない大きさの真っ白い封筒に入った手紙が一通、届いた。初めて見る手書きの文字は、なんとも言えない胸騒ぎを誘った。会ったこともない人から届く手紙、それだけで充分なくらい、その先の旅の始まりを予感させる。その絵の佇まいをひとつひとつ撫でながら、わたしの心はもう決まっていた。出会いというのは、抗えるものではない、と、何の根拠もなく確信するときがある。きっと、生まれてから死ぬまでに出会う人は、予め定められているに違いない、と。渡邉良重さんとの縁は、その象徴とも言える。あの日から現在に至るまで、片手の指に収まるだけしか対面していないにもかかわらず、時に深く、知る由もない彼女の吐息のリズムまでも、親密に感じてしまう錯覚をおぼえる。人の描いた絵を託されるというのは、たましいを差し出されるのと似た行為なのだから、当然かもしれないが…。あまりにも、真っ正面から、そのたましいをくれたものだから、こちらとしても、見せかけで答えられるわけもなく、悶々とした日々がそこから始まった。その瑞々しい絵たちに呼応する言葉が見つからないまま、数ヶ月が過ぎたある日、あ、と思いたったとたん、紙の端切れに鉛筆を走らせた。立ち止まることなく、体感ではまるで50秒くらいの出来事のように思えた。最後の言葉を書き付けると、おもむろにハサミを手に取り、文章が生まれた順番通り、一枚一枚の絵にフレーズを切っては、貼り付けていった。すると、ぴたりと、最後の一枚の絵で終了した。ああいう経験は、後にも先にも、たった一度きり。幸福にも、それに目を通した編集者も、良重さんも、これでいい、と許可をくれた。本来なら、違うパターンも見てみたいとか、ここらへんが気に入らないとか、いくらでも、文句のつけどころがあるはずなのに、ふたりとも潔いというか、男前というか、提示したこちらの方が、怖じ気づくほどあっさりと私の一筆書きを飲み込んでくれたのだ。8年という時が過ぎた今もなお、ふらりと立ち寄った書店や、独特の空気が流れる喫茶店や、好きなひとの本棚に秘かにBROOCHが息づいているのを発見するたび、あの白い手紙を手にした瞬間に舞い戻る。旅のはじまりの予感から、心地よい旅の余韻へと移りかわり、ふと思う。案外、人生の決定的な瞬間は、軽快なステップでやってくるのかもしれない。そして、もしもあの手紙が真っ赤な封筒に入っていたら、まったく違うものができていたのか、なんて悪戯に想像すると、抗えない運命も捨てたもんじゃないな、とつくづく感謝してしまう。

Please Put Words to My Picture　　　　　　　　　　　　　　　　　　　　　　　　　　　　Yayako Uchida/Writer and sighboat

One day I received an awkwardly large, pure white envelope with a letter inside. These handwritten characters I was seeing for the first time gave me butterflies in my stomach. I was receiving a letter from someone I have never even met. That alone was enough to make me realize this as the beginning of a journey. Stroking the shapes of that picture piece by piece, my mind had already decided. Though I have no proof, I am convinced there are occasions in which it is not best to resist a chance encounter. There is no doubt that those we meet from the time we are born until our death has been decided beforehand. You can say that my connection to Yoshie Watanabe is symbolic of that. From that day to the present one, though the number of our meetings can be counted on the fingers of one hand, I can at times intimately recall feeling the rhythm of her breathing though I should have no right to that information. Though perhaps obvious, it is because being entrusted with a painting someone has done is similar to being presented with a spirit… And because that spirit was given in such a straightforward manner, I too could not simply answer with a lie: from that point my days of agonizing had begun. Months passed without finding language complimentary to those vibrant paintings, and then one day, having decided, I ran my pencil on scraps of paper. Without pause, my body felt as if this was an event of only 50 seconds. Having written down the final words I gently took into my hand the scissors, and in the order those passages were born, cut the phrases and passed them onto each illustration. And then, suddenly, the painting for the final page was completed. That kind of experience was a one-time event, never to occur again either before or after. To my joy the editors and Miss Yoshie looked through it, giving their praise and permission. Normally one wants to see different patterns or is not particularly fond of a certain section. Despite usually being plenty of things one can complain about, perhaps it was the courageousness of the two or the handsomeness, it so simply swallowed that which my notes offered I was intimidated. Even now, after eight years, when I casually pass-by a bookstore or a cafe with a unique atmosphere, or each time I discover Brooch hidden away in the bookshelf of someone I am fond of, I return to that moment when I took into my hand that white envelope. Shifting from a feeling of beginning a journey to the pleasant reverberations of one, I suddenly think: the critical moment of one's life may unexpectedly come in a nimble step. And if that letter would have been inside an envelope of deep red I needlessly imagine if something quite different would have come from it, and I am deeply grateful that I did not throw away an inescapable destiny.

記憶をデザインする 　　　　　　　　　　　　　　　　　　　　　　　　　　　　　　　山本容子（銅版画家）

まるで「こだま」のような本だ。大切なモノを包む時の薄紙は表面がツルツルで裏は少しざらついている。そんな紙に七色の色鉛筆のような印象の画材で律儀に書かれた絵とつぶやきみたいな文字が重なり合っている。次のページ、そしてまた次のページが透けているので、ページを操る手をはやめて奥の奥がのぞきたくなる。本は立体的だったことに気がつく。そして、六八枚の薄紙をめくってゆくうちに、絵と文字は「こだま」になって、どの言葉がはじめに発せられたのか、わからなくなるのと同時に、タイトルにあるような、大切なブローチをなくした記憶がよみがえってきて、せつなく懐かしい気分になってしまった。本を閉じた時、この忘れていた気持ちを思い出させてくれたことがブックデザインの力だと思い至ったのだった。薄紙は、記憶のヒダだったのだ。この本の魅力は、絵と文字が同じ重さで一枚の紙の上に乗っていることだ。この分かちがたいバランスを表現出来たのは、絵と文字とデザインが三位一体になっているからだ。これは渡邉良重さんと内田也哉子さんの思いが重ならないと出来ないことだ。二人が「こだま」のように繰り返される音に耳を澄ませながら目の前に拡がる彩やかな風景を眺めている姿が浮かんでくる。でもこのような体験をさせてくれた、渡邉良重さんのブックデザインは、少女のようなロマンチシズムで出来上がっているのではない。実はとても計算されているのだ。確かめたければ、六三枚目の紙をめくってみるといい。彼女のデザイン力のすごさに気がつくから。このお二人にしか出来ない個性的な仕事に拍手を送りたい。　平成17年度講談社出版文化賞ブックデザイン賞選評

Designing Memory　　　　　　　　　　　　　　　　　　　　　　　　　　　　　　　Yoko Yamamoto/Etcher and Painter

The book is like an echo. Its thin paper, like the tissue used to wrap something precious, is smooth and glossy on its surface, slightly rough on the reverse. Across these thin pages are illustrations, carefully drawn in what appear to be rainbow-hued colored pencils, along with sentences, which resemble short murmurings, which overlap one another. Through each page, the next and the next show through, spurring the hand to turn the page and delve ever further in. In reading, the reader becomes aware that a book is, in fact, a three dimensional thing. As I turned these 68 thin pages, and the pictures and words grew into echoes, it became impossible to tell which words came first and which came after. Slowly, as the title suggests, the memory of a lost and cherished brooch was recalled, and as I read I was overcome with a heartrending sense of nostalgia. When I finally closed the book, it occurred to me that I owed the recollection of these forgotten emotions to the strength of the book's design. Its thin pages were like creases in memory. Part of the appeal of this book comes from the fact that the pictures and words are placed with equal weight upon the same page. This intrinsic balance is only made possible because picture, word and design come together in a single trinity. Without the imagination of both Yoshie Watanabe and Yayako Uchida it would be impossible. As the reader lends their ear to the reverberating "echoes" of these two artists, an image arises of a figure gazing out upon beautifully vivid scenery which spreads out before the eye. Yoshie Watanabe's book design, however, which creates this experience for us, is not merely a little girl's romanticism. It is, in fact, very calculating. If you don't believe me, turn the pages for yourself. You won't fail to be impressed by Watanabe's sense of design. No other two artists could produce such a unique work. I sincerely applaud them.

-2005 Kodansha Publication Culture Awards Kodansha Award for Book Design Selection Commentary

realized I forgot something

When I was wandering around the world

Y

LITTLE MORE_picture book_brooch (2006) Y Watanabe D-BROSのカレンダー「brooch」から生まれた絵本。文は内田也哉子さん。紙の透けを利用して物語が進んでいきます。NY ADC・GOLD, One Show Design・GOLD, 講談社出版文化賞・ブックデザイン賞を受賞。This picture book was inspired by D-BROS' "brooch" calendar. Words by Yayako Uchida. The story proceeds by making use of the paper's transparency. Gold winner of N.Y. ADC, One Show Design, and the Kodansha Publication Culture Award for Book Design.

Once upon a time

CLASSICS THE SMALL LUXURY _ handkerchief〈2003〉Y. Watanabe　六本木ヒルズの中にあるハンカチ屋さんから、クリスマスをテーマに依頼されデザインした6枚のうちの1枚。A Christmas themed piece for a handkerchief store "CLASSEICS the Small Luxury" in Roppongi Hills. One of six designs.

■ R&Y

THE NUTCRACKER_scarf for the film (2010) R. Uehara & Y. Watanabe くるみ割り人形のオーケストラ演奏の際に上映する映像を作る為、まず一幕分のスカーフを作りました。映像はそのスカーフを特殊な方法で万華鏡のように蓮井幹生さんに撮影していただきました。Before creating this film, for display during an orchestral performance of the Nutcracker, we first created the scarves featured within the film. The scarves were photographed by Mikio Hasui using a special method in order to make them appear kaleidoscopic.

Y | LIBERTY_art fabrics_*yoshie* 〈2010〉 Y.Watanabe イギリス、リバティ社の2010年秋冬コレクションのひとつ。D-BROSのカレンダー「あるくにをあるく」の絵をもとにデザイン。上質なコットンに繊細なプリントが施されています。Part of the 2010 A/W collection for Liberty Art Fabrics, of England. The design was based off the D-BROS calendar, "Arukuni wo Aruku (Stroll a Far-off Country)", which was designed by Watanabe. It features high quality cotton and a delicate print. ©Liberty Ltd.

Y

CLASSICS THE SMALL LUXURY _ handkerchief 〈2008〉 Y.Watanabe 六本木ヒルズの中にあるハンカチ屋さんの5周年記念のハンカチのデザイン。プリントや刺繍、ベトナム刺繍、丸縁など贅沢な仕様で製作しました。 Five year commemorative handkerchief for a handkerchief design store "CLASSICS the Small Luxury" in Roppongi Hills. The print, embroidery, Vietnamese embroidery and round edging all contribute to a luxurious finish.

MIKIMOTO_window display 〈2007〉 Y.Watanabe ミキモトのウィンドウディスプレイ。全体のディレクションをミキモトの新保智子さんが、アクリルの中の真珠が生まれて運ばれる物語のアートワークを渡邊が担当しました。Mikimoto window display. Overall direction was handled by Mikimoto's Tomoko Shinbo, while Watanabe was responsible for artwork depicting a story of pearls born and carried amidst an acrylic sea.

R & Y

HERMÈS "as a research project for the Innovation Direction, Hermès" (2009) R. Uehara & Y. Watanabe エルメスのリサーチプロジェクト「プレシャス・ペーパー」に招待参加した時のコンセプトワーク。エルメスのスカーフサイズと同じ90cm×90cmのレースペーパーのガーデンを作り、自由にちぎってアクセサリーにするという提案をしました。Concept work created while participating, by invitation, in the Hermès research project, "Precious Paper." The idea behind this design was a lace paper garden the same 90cm x 90cm size as a Hermès scarf, torn freely in order to make an accessory.

FACE-flower.com

FACE

A FLOWER IS A FACE.
BEAUTIFUL. FUNNY. AND POISONOUS AT TIMES.

www.face-flower.com

フェイス

ラフォーレ（p.128）や雑誌「流行通信」での連載「花葉術」（p.184-185）など、クライアントワークからプライベートワークまで植原と共に制作してきたクリエイター青木むすびさんが、クリエイティブ・ディレクター／マーチャンダイザーを務めるフラワーショップ。アートディレクションを植原が担当しました。有楽町ルミネ1Fに2011年10月にオープンした、細く小さなお店で、箱にアレンジしたフラワーアレンジや雑貨が販売されています。店名"フェイス"は、花は顔のようにその人の心を表わすという意味に加え、1Fの人通りに面した場所にあることから、ルミネの顔にしていきたいという想いも込められた店名になっています。欧文ロゴはフィニッシュまで手描きで描かれ、ショッピングバッグなどのグラフィックは、花が並び首をかしげ微笑んでいるようなイメージに。店に敷いたタイルにも展開されています。フラワーショップはかわいく甘くなってしまいがちなのですが、コントラストの強いシャープなモノクロ写真や、固めの書体を使うことで全体のバランスを取っています。写真とウェブのムービーは写真家の新津保建秀さんにお願いし、散り、朽ちていく花のハイコントラストな映像は、花の持つ美しさや儚さが表現されています。

Face Uehara has worked with Musubi Aoki on everything from client jobs to private, including projects such as Laforet (p.128), or "Kayoujutsu (The Art of Floral Leaf)," which was a serialization in Ryuko Tsushin magazine(p.184-185). FACE is the floral sheep where Aoki works as creative director and merchandiser. My responsibility was art direction. As a small and narrow store which opened, in October, 2011, on the first floor of Yurakucho Lumine, it sells flowers arrangements set in boxes as well as sundry goods. The name "FACE" was chosen for two reasons. Like the face, flowers express the heart of the person holding them. In addition, looking out from the first floor on foot traffic, the store itself aims to serve as a face for Lumine. The European text logo was drawn entirely by hand, while the graphics found on the shopping bags and elsewhere were modeled after an image of flowers lined up, their heads tilted and smiling. This imagery carries over to the tiles laid within the shop. Since a flower shop runs the danger of appearing overly cute or sweet, I used also used elements such as sharp, high-contrast monochrome photographs and stiffer fonts for balance. The photographs and online videos were created by photographer Kenshu Shitsubo. These high contrast images of flowers as they scatter and fade beautifully express the exquisite transience of flowers.

FACE_1.shop graphics 2.web design〈2011〉 R.Uehara

NATUREROID

GRECANA_paper_2012 s/s natureroid 〈2011〉 R. Uehara

MOVING TEXTILE *gredecana* gredecana 2012 S/S COLLECTION "NATUREROID"

gredecana

gredecana

gredecana 2011 S/S COLLECTION
"Pond"

A pond as small as a puddle
has appeared in the Gredecana forest.
It has layers of the present
reflecting upon the surface
and the past resting underneath.

gredecana is a
lush forest
of creation,
attracting
textile lovers:
designers,
craftsmen
and wearers

MOVING TEXTILE

gredecana

GREDECANA_openig graphic tool,package 〈2010〉 R.Uehara

gredecana is a lush forest of creation, attracting textile lovers: designers, craftsmen and wearers

MOVING TEXTILE

gredecana

Gredecana is a lush forest of creation, attracting textile lovers: designers, craftsmen and wearers

MOVING TEXTILE *gredecana*

GREDECANA This lifestyle brand is based on textile designer Kanako Kajihara's original textiles. Uehara has been responsible for art direction since the brand's inception. Sponsored by Issey Miyake, Kajihara studied textiles abroad in England. After returning, she was faced with the sad reality of Japan's inferior position in the textile industry, and the lack of places for superior artisans in Japan. If this decrease for demand in textiles continued then it was possible that these artisans might disappear altogether. In order to combat this trend, Kajihara gathered together these people together in order to make new fabrics, and proactively pursued sales overseas. Thanks to Japanese craft, and Kajiwara's superior taste, their cloth has now been used by companies such as Prada and Gucci. As art director, I considered it important that GREDECANA become a hub linking craftsmen and designer, factory and clothier, fashion and textile. The 'G' logo mark was designed to give the impression of power radiation outwards from the core, while also giving the impression of people gathering together from without. The concept visuals feature a small drawing of a stream, which conveys the worldview of GREDECANA. The image was drawn by Megumi Yoshizanu from a photograph which I had taken. This image was based off an actual experience of Kajihara's as a child. According to Kajihara, as a child she was captivated by a beautiful stream near her house, and would go to stare at it nearly every day. However, the stream was so narrow that she worried it might disappear someday. So every day, in order to prevent this, she would carry a large pile of salt and scatter it into the stream. She thought that by pouring this salt into the stream she could cause it to swell and grow. Of course it's a funny story, but Uehara can't help but feel that that little girl with the salt holds the seeds of the woman who works so hard today to swell up the disappearing thread of Japan's textile industry. That is why I made that memory into the symbolic imagery of the brand's concept visuals. The thin streams gradually weave together as they grow and broaden into the sea. This expanding worldview was the basis behind my brand direction for GREDECANA.

グリデカナ

テキスタイルデザイナー梶原加奈子さんのオリジナルテキスタイルをベースに展開するライフスタイルブランド。植原はブランドの立ち上げ時からアートディレクションを担当しています。梶原さんはイッセイミヤケを経てテキスタイルの勉強のためイギリスへ留学。帰国後、日本のテキスタイル業界の地位の低さと、優秀な職人たちの活躍の場が少ない悲しい現実を知らされます。このままテキスタイルの需要が減り、職人たちが消えてしまうかもしれない状況を見直すべく、梶原さんは職人たちと共に生地をつくり、海外へ積極的に営業活動を行ない始めました。日本の技術と梶原さんのセンスは徐々に認められ、プラダやグッチなどに生地が採用されていきました。アートディレクションをするにあたり、植原は、グリデカナが職人やデザイナー、工場、生地屋など、ファッションとテキスタイルを繋ぐ中心／ハブになるべきだと考えました。ロゴマークのGは、そうした中心から外側へ向かうパワーと、一方で人が集まってくるようにという想いを込めてデザインしました。グリデカナの世界観を伝えるコンセプトビジュアルには、小さな川が描かれています。植原が撮った写真をもとに吉實恵さんに描いていただきました。このビジュアルは梶原さんが子どもの頃の実体験がもとになっています。彼女は家の近くにあった綺麗な小川に惹かれ、毎日のように眺めていたのですが、その小川があまりにも細く消えてしまいそうで、なんとかしようとたくさんの塩を毎日のように撒いていたそうです。塩を撒けばそこは水が溢れる海になる、そう思っていたのだそうです。実際は笑い話で終わるのですが、植原は、消え入りそうなテキスタイル業界の線を太くしようとしている今の姿を暗示していたかのような話だと感じ、その想いを象徴する風景をブランドのコンセプトビジュアルとして制作しました。細い水がどんどん編み込まれるように広がっていき、最後は海へ。そうした世界観の広がりをイメージしながらブランドをディレクションした仕事です。

GREDECANA_opening graphic tool, package〈2010〉 R.Uehara

こころに花を。

une nana cool

R & Y

UNE NANA COOL_ 1.poster 〈2003〉 2.poster 〈2010〉 R.Uehara & Y.Watanabe

R & Y

D-BROS _ 1.wrapping paper 〈2008〉 2.shopping bag 〈2005〉 R.Uehara & Y.Watanabe

Y UNE NANA COOL_applique 〈2005／2006〉 Y.Watanabe

une nana cool

わたしを動かすのは、わたしなのだ。

une nana cool An underwear brand created by Wacoal in March, 2001. Designed for girls who want to change their underwear the way they change their clothes, these garments hold a simple and chic essence. We received the request came from a person at Wacoal who had seen our work for Caslon. Our original theme for the line was that it cheers on the energetic young girl as she goes after life. Despite being an underwear store we aimed for an extroverted and active image. Branding began with naming and a concept, "une nana cool." A girl on the hipper side of things. Creative Director Satoru Miyata (DRAFT Co., Ltd.) worked on brand trending, Art Directors Watanabe and Uehara were responsible for visuals, SUN-AD's Chiaki Kasahara handled copywriting and shop designed by Hisae Igarashi. Since the brand was designed for women, naturally Watanabe's sense came first. Together we designed everything relating to the brand and store, including business cards, envelopes, shopping bags, catalogues and more. The store's opening appears to have had a significant impact worldwide; afterwards several new underwear stores began to open. For over ten years we've continued to create their season posters, still holding true to the two catch copy phrases created at startup, "I'll be able to fly, someday," and "Let your body sing." Hanging these posters inside une nana cool is one of the vital points to their branding. When the goals and ideals of a new brand begin to meet reality, they can't help but begin, little by little, to slip. Which is why Miyata came up with the idea to hang these posters inside the store. Hanging them inside helps to give birth to communication between the customers and the brand, the customers and the staff, and the staff and the brand, amassing a core relationship which allows a designer to continue with the brand long thereafter. This work is a good example of our applying our creativity to a brand and designer which had already built up a firm reputation of trust.

ウンナナクール

2001年3月にワコールから生まれたアンダーウェアブランド。下着も洋服のように着替えたいという女の子の気持ちを大切にし、シンプルでおしゃれなエッセンスを効かせた下着をつくっています。キャスロンの仕事を見ていたワコールの担当者から依頼を受け、元気で頑張っている女の子を応援しようというテーマのもと、下着の店ではあるけれど外に向かう明るい活発なブランドを目指しました。そして、ちょっとかっこいい女の子を意味する「une nana cool」というネーミングとコンセプトの設計からブランディングが始まります。CDの宮田識さんがブランドの向かう方向性を、ADの渡邉と植原はビジュアル表現を、コピーはサン・アドの笠原千昌さん、ショップデザインは五十嵐久枝さんが担当。女性向けのブランドなため、自ずと渡邉の表現テイストを中心に進んでいきました。二人は、名刺や封筒、ショッピングバッグ、カタログなど、ブランドと店舗に関わるものすべてをデザイン。オープン後、業界への影響も大きかったのか、さまざまな下着屋がオープンしていきました。私たちは「空くらいいつか飛べるだろう」と「からだが歌うの」という立ち上げ初期にできたコピーを今でも大事にしながら、オープンから10年以上シーズンポスターをつくり続けています。そしてそのポスターにウンナナクールのブランディングの大きなポイントがあります。立ち上げたばかりのブランドが掲げた目標や理想は、現実と向き合った時、どうしても少しずつずれ始めてしまいます。そこで宮田さんはポスターを店内に貼ることを考えました。ポスターがあることで、お客さんとブランド、お客さんとスタッフ、スタッフとブランドに至るまでなんらかのコミュニケーションが生まれ、そこにデザイナーがブランドと長く付き合うための関係の核を築くことができるのです。この仕事は、私たちにとって、ブランドとデザイナーが信頼を築き上げながらクリエイションをしているブランディングデザインの好例の一つだと思っています。

UNE NANA COOL_poster〈2011〉 R.Uehara & Y.Watanabe

caslon

R & Y

CASLON_ 1.cup&saucer 2.glass 3.mat 4.bandana 5.paper bag for bread 〈1999〉 R. Uehara & Y. Watanabe

R & Y

CAS_CN_ 1.logomark, signboard 2.shop 3.poster (1999)　R.Uehara & Y.Watanabe

キャスロン

仙台でモスバーガーのフランチャイズを展開する川井善博さんとドラフトの代表宮田識さんが、1999年に共同で立ち上げたベーカリー＆レストラン＆プロダクトショップ（*）。元々仕事を共にしてきた川井さんから、何か一緒にお店をやりませんかと声をかけられ、ゼロからお店をつくり始めました。パン屋をやることが決まった段階で渡邉がアートディレクターとして加わり、さまざまな複合ショップの案が検討されるなか、二ヶ月後に植原も参加。植原にとって最初のアートディレクターとしての仕事であり、渡邉とチームを組んだダブルADスタイル最初の仕事でした。店名「caslon」は、グラフィックデザイナーが大きく関わるお店であることから、18世紀以降大きな影響力を持ち続ける、音の響きもいい書体の名前からつけられています。ベーカリーとレストラン、そしてD-BROSを中心としたプロダクトコーナーを併設することが決まり、1999年、私たちはポスターからショッピングバック、玄関マット、バンダナ、エプロン、メニュー、食器まで、お店のためのあらゆるツールをデザインすると同時に、商品数の少なかったD-BROSの新作10数種を制作。キャスロン書体を使ったロゴは、ロゴ自体がキャラクターとして様々に展開していくように考え、統一されたブランドイメージを与える役割を果たしながら、固定され過ぎない広がりのあるデザインを目指しました。

* 現在、プロダクトショップは営業しておりません。

Caslon　　A bakery and designer merchandise store* created in 1999 through the joint efforts of Yoshihiro Kawai, who developed the Mos Burger franchise in Sendai, and Satoru Miyata of DRAFT Co., Ltd. The two, who once worked together, began to develop the store from scratch after Kawai proposed creating a new shop together. Once a bakery was decided on Watanabe was added as art director, various plans for a composite shop were considered, and two months later Uehara also came on board. This was Uehara's first job as an art director, and also the first time the two of us joined in double direction. The name Caslon —— a font style which has remained influential since the 18th century —— was chosen for its pleasant ring, and because of the store's close association with so many graphic designers. In 1999 a final plan of joint bakery, restaurant and designer merchandise corner focusing on D-BROS products was decided upon. We designed all the tools necessary for the store, from posters, shopping bags, welcome mats, bandanas, aprons and menus all the way down to cutlery, and at the same time expanded the still small D-BROS product line by several dozen. We wanted the logo, which incorporates Caslon script, to be adaptable to future developments, such as use as a character. Our aim was for a design which imparts a unified brand image, but without becoming overly fixed or losing its open potential.

* Currently, the merchandise store is no longer in operation.

caslon

ABCCDEFGH
IJKLMNOP
QRSTUVW
XYZ&ab def
ghijklmnopqrs
tuvwxyzfifffiffi
ffl1234567890
$.,"-:;!?""

R & Y

Pass the Personal Culture
Pass the Baton

PASS THE
BATON

PASS THE BATON_wrapping paper 〈2009〉 R.Uehara & Y.Watanabe

キギさんとの出会い　　　　　　　　　　　　　　　　　　　　　　　　　　　　　　　　　　　　　　遠山正道（スマイルズ）

キギさんは、数年前のシアタープロダクツのショーの時に紹介を受けましたが、私は初対面の植原さんの強烈な素敵ぶりに完全にやられてしまいました。渡邉良重さんも、絵本がとても好きで憧れていたところに、ナマの良重さんは更にその永遠なる少女性の控えめなる素敵ぶりで、二人合わせた控えめかつ強烈な素敵光線に打たれてしまったわけです。そうそう、それに、お二人ともSoup Stock Tokyoのファンだ！と目をハートマークにしてくれて、そんなことで距離が近づいたような気がします。なかば興奮気味にオフィスに戻り、二人のことを調べましたが、シアタープロダクツ、絵本、ビニール花瓶以外、市販品や代表作が見当たりません。社内のクリエイティヴのメンバーに知らせようと思ってもなかなか示しにくい。その頃の私たちは、最初に私がSoup Stock Tokyoのマークを描いて以来、良くも悪くもクリエイティヴは全て内製化しておりました。そんなことで初の外部依頼に私も緊張。最初の打合せには 何と4人でいらっしゃるというので、それは困ります、だってそんな立派なクライアントじゃないし予算も無いから1人か2人で最低限な感じでお願いします、なんてお願いしたが4人でいらしてドキドキでした。最初の取組みはJALさんへの新しい機内食のプレゼンでしたが、出来たものは「さすがプロ！仕上がりが全然違う！」と、社内のクリエイティヴのメンバーも秒殺で感服したものです。良重さんの「スープ子さん」は、何故か機内食関係で一緒に行ったハワイでプレゼンがあり、おまけ候補のようだったその案に私はまたも一目惚れ、その場で「スープ子さん」と命名されました。その後のPASS THE BATONの一連のデザインも本当に素晴らしいものです。片山正通氏のインテリア、そして現キギさんのデザインワーク、こういった本気のものに囲まれて私はどっぷりと幸せを感じました。特にPASS THE BATONの文様は秀逸です。私は「現代の文様」をオーダーしました。古い掛け軸などに現代の文様を上からプリントし全てをリデザインしようと思いましたが、その文様があまりにエレガントで綺麗だったので、何かの上に乗せる蛮行は止めて、単独の象徴としました。キギさんとの打合せは、出てきた案に私が顔をしかめて、その場でどんどんと変更しその場で作品が出来上がっていく、なんてこともある非常にエキサイティングかつ贅沢な仕事であります。これからもまた控えめかつ強烈な素敵世界を一緒に展開させるのが今から楽しみでなりません。WITH LOVE。

My First Encounter with Kigi　　　　　　　　　　　　　　　　　　　　　　　　　　　　　　　　　Masamichi Toyama / Smiles

My first introduction to Kigi came many years ago at a THEATRE PRODUCTS show. I was smitten from the very outset by Uehara's incredible intensity and style! I had been a big fan of Yoshie Watanabe's picture books as well. In person, she was even more the eternal young girl, charming and reserved, than I had imagined. Together, the two shone with a spectacular light, simultaneously reserved and intense. And, lucky for me, they were both Soup Stock Tokyo fans! When I heard that, my eyes turned heart-shaped and floated out of my head. The ice had already been broken!I went back to the office, pleasantly excited, in order to look further into the pair. But outside of THEATRE PRODUCTS, the picture books, and their vinyl flower vases, I couldn't find any other large, representative works. I wanted to let the creative team at my company know about them, but I didn't know quite how to explain. You see, I had been the one to draw the original logo for Soup Stock Tokyo, and ever since then, for better or worse, we had been taking care of the creative work ourselves. I was nervous about making our first outside request. When they sent four people to our first meeting, I didn't know what to do. We weren't a big client, the budget was small, and so I asked them to just bring the minimum, one or two people. When I saw four my heart started pounding double time. Our first initiative was a presentation for new in-house meals for JAL. They instantly won over the creative team. "Now that's how the professionals do it!" they said. At some point we went to give a presentation for the meals in Hawaii, and Yoshie's "Soup-ko san" drawing was in one of the proposals. I was taken with it at first sight. We gave her the name, "Soup-ko san," there on the spot. The designs they did for PASS THE BATON afterwards were every bit as amazing. Being surrounded by all this genuine talent, by the interior design of Masamichi Katayama, and with what is now Kigi's design work, absolutely fills me with happiness. The pattern they did for PASS THE BATON is phenomenal. I had wanted something modern. I wanted to print a modern pattern on top of old tapestry, and just redesign the whole thing, but the pattern they created was so elegant and beautiful that I decided that printing it atop something else would be barbaric. I decided to use it as an independent symbol instead. When we meet with Kigi, we begin by pouring over the proposals, and as we work the ideas begin to change then and there, and the pieces begin to take shape. It's such incredibly exciting, stupendous work! I can't express how much I look forward to being able to develop it in the future, this world of simultaneously reserved and intense wonder. With Love.

R&Y

PASS THE BATON_ 1. package 〈2011〉 2. package 〈2011〉 3. scarf 〈2010〉 4. reprint shirt 〈2010〉 5. reprint t-shirt 〈2010〉
6. necktie 〈2010〉 7. necktie pin 〈2010〉 8. reprint t-shirt 〈2010〉 R.Uehara & Y.Watanabe

PASS THE BATON_1. business tool 〈2009〉 2. shopping bag 〈2009〉 3. packing tape 〈2009〉 4. wrapping paper 〈2009〉
5. reprint tableware 〈2010〉 6. original goods 〈2010〉 R.Uehara & Y.Watanabe

R&Y

R & Y

PASS THE BATON

パス ザ バトン

2009年9月に丸の内、翌年4月に表参道ヒルズにオープンした新しいスタイルのリサイクルショップ、パス ザ バトン（以下PTB）。不要品をただ売り買いする場所ではなく、個人の思い出や痕跡など、物に形を変えたパーソナルな文化や歴史を受け継いでいく場所を作りたいという、オーナー遠山正道さんの想いから始まっています。スープストックトーキョーなどを手がける遠山さんから依頼を受けた私たちは、「このリサイクルの仕組みを社会のインフラにしたい」と考える遠山さんの言葉とラフスケッチをもとに、誰もが直感的に理解できるようコンセプトをわかりやすく表現したロゴを提案。"O"部分の循環する矢印型リサイクルマークに目がいくようにデザインし、バトンを持つ手のイラストは写真をもとに渡邉がイラストにしました。また、PTBにおけるディレクションは、ひとつのロゴマークやグラフィックイメージを単純に反復するのではなく、包装紙やパッキングテープ、お客様へ送る封筒に写真やイラストなどの要素を増やし、一見してわからないほどのディティールを作り込むことで複雑な"味わい"を表現しようと考えました。リサイクル品やB級品など、何にでも刷ることのできるデザインパターンをというオーダーに応えたイラスト（右ページ上写真）は、植原が描いたラフを渡邉がイラスト化したもので、店内の壁画を始め、包装紙や皿、カップなど様々なものに展開されました。そうした多様な表現自体が、個性的なモノやコトが集まるPTBというショップにマッチすると考えたのです。強い美意識をもつ遠山さんとの仕事は、私たちのアートディレクションで完結するのではなく、いつも互いのクリエイティビティを引き出し合いながら行なわれています。

PASS THE BATON　　PASS THE BATON (PTB) is a new style of second-hand shop first opened in September, 2009, in Marunouchi and then April of the following year in Omotesando Hills. Much more than a mere buying and selling ground for things which are no longer necessary, PTB grew out of the owner, Masamichi Toyama's desire to create a place where the thoughts and footmarks of the individual could be captured as items and their personal culture and history carried on. "I want to make this form of recycling part of the social infrastructure." After receiving this request from Mr. Toyama, who is the man behind businesses such as Soup Stock Tokyo, we used his words and rough sketches as a basis to set about creating a logo which would convey the concept in a direct and easy to understand manner. We designed a circular arrow recycle mark in order to catch the eye, and Watanabe used a photograph to create the illustration of a hand holding a baton. For the art direction inside PTB, we decided that rather than simply repeat a single logo mark or graphic over and over, we would create a more complex environment incorporating elements such as wrapping paper and packing tape, envelopes the customer might send decorated with different illustrations, ample photography and drawing, and complex detailing not immediately dissectible at a glance. One illustration (upper right fig.), which was designed to be printable on recycled articles, B-grade goods, or on anywhere else desired, was illustrated by Watanabe from a rough sketch done by Uehara. It was first applied to a wall of the store, and spread from there to wrapping paper, dishes, cups and elsewhere. Our thinking was that this wealth of expression and form would be a perfect match for the unique collection of personal items and character found at PTB. Mr. Toyama's own sense of aesthetics is strong. Working with him was a satisfying experience, the end product due not to our own art direction only, but instead to a constant and mutual exchange of creativity.

PASS THE BATON_ 1.logomark 〈2009〉 2.shop graphics 〈2010〉　R.Uehara & Y.Watanabe

植原さんとシアタープロダクツのコミュニケーション　　　金森 香（シアタープロダクツ）

植原さんに、シアタープロダクツのグラフィックワークを通年でお願いするようになって、7年たった。コレクションのインビテーション、新作立ち上がりのポスター、催事のおしらせハガキ、ショップカード、便せん、スタンプカード、ウェブサイトのディレクション、そしてときにテキスタイルのグラフィック……等々。いうまでもないが、植原さんは、単に当社の『広報印刷物』平素の平面的表現をやっているというだけでない。「どのようにシアタープロダクツの活動や商品メッセージを人々に届けるか」ということについて、当ブランドのこれまでの変遷をふまえ、クリアな客観性と、同志（おそれながら）の切実さを持って解を導き出す。毎度のコレクション前は、アイデアソースという、なんだかゴミと抽象とファウンドオブジェクトだかみたいなにっちもさっちもいかなそうな感じで混沌としたのをこちらは差し出すことが多いのだが、植原さんは、そこから非常にロジカルに、シンプルではっきりとした骨子をもったプランを立てる。その過程における素朴な問答で我々は自分たちを見つめ直し、一体何を作ろうとしているんだろうかと自らを検証することになるのだが、で、その末に、さて植原さんは、えいやー、と一足飛びに何かある一枚絵に虹をかけるような作業をなすって、「こんなんでたよ」的にいっぷくの視覚情報をお作りになる。ファッションは、人々の日常に入り込んでいく力を持っている。その業界の中で、わたしたちは、ファッションをして日常に建物のない劇場を作ろうとしている。そして、植原さんは、そこにうまれる語り始められたばかりの物語をすくいあげ、混沌の情報を整理しながら、また最後に再び見るものを混沌の海へ誘う謎掛けをする。お仕事をご一緒するようになってから、いろいろあった。亀倉雄策賞を当社の年間印刷物で受賞なさったときは、我がことのように、嬉しかった。こんな低予算でいつも迷惑かけて、申し訳ないことの連続でしかなかった植原さんへのお願いごとの軌跡が、何らかの評価を受ける日がくるとは、想像だにしてなかったから。いまも会社の紆余曲折とともに思い出され、怪しい郵便物を抱えて満身創痍で郵便局に持ち込んだ幾数回の夜を想い（不思議な仕様なんで夜間窓口のほうが突破しやすかった……）、泣きそうになる。植原さんのグラフィックワークは、とても触覚的で空間的で、事件を誘発する生命体的な動きをもっている。独自システムで寓話や詩情や物語といったものを、すとん、と現実に落とし込み、密かに重力を操作する。そしてそれが誰かの手元で、奇跡的瞬間をもたらす。そういう時間があといくつ作れるか、どんどん更新されていく世界で、この手元という感覚も、紡ぎ出される物語の手触りも変転していく中、次は何ができるか、まだもうちょっと挑戦を続けていきたいですね、ご一緒に。

Communication Between Uehara and THEATRE PRODUCTS　　　Kao Kanamori / THEATRE PRODUCTS

It's been many years now since Uehara began handling THEATRE PRODUCTS's graphic work for us. He designs our collection invitations, posters for new works, special event post cards, shop cards, writing tablets, on occasion even graphics for textiles… I could go on and on. I think it goes without saying, but Uehara does much more than simply plan the appearance of our printed advertisements. When it comes to what sort of approach to take, what to sell, or what sort of fantasy to impart, he follows the course our company has tread up to date and offers solutions with a clear, objective mind and the urgency (if I can be allowed to say so) of a comrade and friend. Before every show we bring out our ideas in a confused heap made from trash and abstraction and found objects, and somehow from that chaos Uehara creates an incredibly logical, clear and dependable plan. By asking questions he makes us reevaluate ourselves and examine just what, exactly, it is that we are making. The end result of this back and forth, at last, is that Uehara leaps to his feet to draw some picture, colorful like a rainbow, as if to process all that information as one visual pulled from the mess. Fashion has the power to enter into and saturate everyday lives. Our goal, in fashion, has been to create a theatre without the physical playhouse, a theatre for the everyday. What Uehara does, then, is to scoop up the stories newly born in this theatre, sort through the disorder, and return with a riddle which seems to invite one into the sea of chaos. A lot has happened since we first started working together. When he won the Yusaku Kamekura Design Award for that year's print work for our company we were overjoyed! With our low budget I know we've been a regular source of trouble to Uehara, but we never imagined that one day someone would take the time to appreciate the evidence left behind of all our selfish requests. When I remember all the ups and downs the company has faced, all those nights, battered and bruised, suspiciously odd packages in hand as we trudged to the post office (I know it sounds odd but they're easier to get through at the night window), I start to feel misty eyed. Uehara's graphic work is extremely tactile and spatial, possessed of a living energy capable of sparking events into motion. With his own unique approach, he drops allegory and poetry and fantasy smack into reality, secretly manipulating their gravities. When these pieces reach a person's hand they can bring about moments of miracle. How many more of these moments can we make? As the world continues to change, as this miraculous feeling of closeness changes, as the tactile touch of the stories he spins out begins to evolve, what will we be able to create next? That's a challenge I want to keep facing for a little while longer. To face it together.

THEATRE PRODUCTS_1.invitation,poster_ *2009 s/s country* 〈2008〉　2.poster_ *2010 s/s bombay* 〈2010〉　3.t-shirts 〈2008〉　4.invitation,poster_ *2010 s/s bombay* 〈2009〉　5.book_ *the book of theatre products* 〈2007〉　6.wrapping paper,poster_ *osaka 120 days shop in graf* 〈2008〉　R.Uehara

R

R

THEATRE PRODUCTS _ 1.poster _ 2010 s/s camouflage 〈2009〉 2.poster _ 2010 a/w boutique 〈2010〉 3.poster _ 2010 a/w boutique 〈2010〉 4.poster _ 2011 s/s camouflage 〈2011〉 5.poster _ 2011 s/s bombay 〈2009〉 6.poster _ 2011 a/w housing 〈2011〉 7.poster _ 2011 a/w housing 〈2011〉 8.poster _ 2008 a/w cyndi 〈2008〉 9.poster _ 2008 a/w cyndi 〈2008〉 10.poster _ 2009 a/w joy 〈2009〉 11.poster _ 2009 a/w joy 〈2009〉 12.poster _ 2009 s/s country 〈2008〉 13.poster _ 2009 s/s country 〈2009〉 14.poster _ 2010 s/s bombay 〈2010〉 R.Uehara

BALLET DE LA MER

THEATRE PRODUCTS 2012 S/S COLLECTION
"BALLET DE LA MER"

www.theatreproducts.co.jp

THEATRE PRODUCTS 2012 S/S COLLECTION
BALLET DE LA MER

THEATRE PRODUCTS_poster_2009 a/w joy ⟨2009⟩ R. Uehara

2009 A/W COLLECTION

CAMOUFLAGE

THEATRE PRODUCTS 2011 S/S COLLECTION "CAMOUFLAGE"

THEATRE PRODUCTS_invitation, poster_2011 s/s *camouflage* 〈2010〉 R. Uehara

THEATRE PRODUCTS 2011 S/S C

THEATRE PRODUCTS_poster_2011 a/w housing ⟨2011⟩ R. Uehara

HOUSING

THEATRE PRODUCTS "As long as we have clothes, the world is a stage!" Using this concept, designers Akira Takeuchi, Tayuka Nakanishi and producer Kao Kanamori created the fashion brand, THEATRE PRODUCTS, in 2001. THEATRE PRODUCTS clothing incorporates not only color, material, texture, silhouette etc., but is created with an ever new world outlook which also incorporates the space and time of the wearer into the design. With boat-top fashion shows, AR system driven presentations, moving the entire company per venue, and exhibitions where daily tasks become the works themselves, THEATRE PRODUCTS is constantly carrying out experimental and revolutionary steps in order to test just how far they can show off their clothing. My first encounter with THEATRE PRODUCTS came when I (Uehara) visited their first exhibition entirely by accident. At that time, Kanamori was looking for a direct mail designer and saw my business card among those who had come to the exhibition. By chance, it turned out that Ms. Kanamori possessed many of the D-BROS products which I had designed. Until 2005 I only did work for them occasionally, but starting from 2006 I assumed responsibility as art director for their season visuals. The THEATRE PRODUCTS logo was created by the designers themselves, but I thought it was an excellent logo and decided to make large bold use of it. If we think of the logo as THEATRE PRODUCTS' national flag, then the season visual posters were like ensigns hoisted above the battlefield of fashion. Also, direct mailings and posters can be received directly, opened and touched, giving the concrete feel and sound of paper. My goal has always been to create designs which touch on all five senses. As a small-scale independent brand, rather than utilize mass advertisements we chose to approach those close to the brand in a friendly and polite manner. Every season direct mailings are carefully sent out to customers, friends, stylists, editors, etc. In 2009 I was honored with the 11th Yusaku Kamekura Design Award for this work.

シアタープロダクツ

「洋服があれば世界は劇場になる」をコンセプトに、デザイナー武内昭さんと中西妙佳さん、プロデューサー金森香さんが2001年に設立したファッションブランド。シアタープロダクツの服は、色や素材、風合い、シルエットだけでなく、その服を着る人や時間、空間なども含めてデザインされ、常に新しい世界観をつくり出しています。船上でのファッションショーやARシステムを使ったプレゼンテーション、会社ごと会場に引越し、日常業務自体を作品にした展覧会を開催するなど、服をいかに見せるかということにおいて、実験的で革新的な活動を行なっています。出会いのきっかけは、最初の展示会に植原が偶然訪れた時でした。その時、金森さんはDMのデザイナーを探していて、展示会に来た人の中から植原の名刺を発見。偶然にも金森さんは植原がデザインしたD-BROSの商品をいくつも持っていたそうなのです。2005年までは幾度かのスポットでの仕事でしたが、2006年からシーズンビジュアルのアートディレクションを担当し始めます。シアタープロダクツのロゴは彼ら自身がデザインしていますが、とても良いデザインだと思ったので、大きく大胆に扱うことをルールとしました。シアタープロダクツのロゴが国旗だとしたら、シーズンごとにつくるポスタービジュアルはファッションの戦場に掲げる軍旗のようなものだと思っています。一方DMやポスターは直接手元に届き、開けて触るもの。紙の質感や音を感じてもらえる。そういう五感に響くようなデザインがしたいといつも心がけています。シアタープロダクツは小規模なインディペンデント・ブランドであり、マス広告を打てない分、近くの人にできるだけ丁寧なコミュニケーションをしていこうと皆で考え、顧客を始め、友人やスタイリスト、編集者などへ毎シーズン丁寧なDMを送ることを徹底してきました。2009年、この仕事において第11回亀倉雄策賞を受賞することができました。

THEATRE MUSICA_poster〈2006〉THEATRE PRODUCTS_invitation_*2006 a/w compact is beautiful*〈2006〉 R.Uehara

THE CLASSIC, THE MOST AVANT-GARD

We are at the end of Renaissance.

by Stefan Winter in 2006

Seja marginal, seja herói.

by Caetano Veloso em 1968

MUSICA! TILL I DIE.

http://www.theatremusica.com/

RIVE WORKS_sticker poster_*implosion ↔ explosion* ⟨2012⟩ R. Uehara

January

sunday		2	9	16	23 30
monday		3	10	17	24 31
tuesday		4	11	18	25
wednesday		5	12	19	26
thursday		6	13	20	27
friday		7	14	21	28
saturday	1	8	15	22	29

LETTER IN JANUARY

Daffydowndilly has come up to town, In a fine petticoat and a green gown.

DB D-BROS 2011

October

LETTER IN OCTOBER
I had a little nut tree, nothing would it bear
But a silver nutmeg and a golden pear.

sunday		2	9	16	23	30
monday		3	10	17	24	31
tuesday		4	11	18	25	
wednesday		5	12	19	26	
thursday		6	13	20	27	
friday		7	14	21	28	
saturday	1	8	15	22	29	

R&Y

D-BROS_flower vase_*hope forever blossoming* ⟨2011⟩ R.Uehara & Y.Watanabe

10th ANNIVERSARY
Clematis no Oka

R & Y

CLEMATIS NO OKA_poster_10th anniversary 〈2012〉 R. Uehara & Y. Watanabe

R & Y

D-BROS _ cup and saucer _ mirror 'waltz' (2005) F. Uehara & Y. Watanabe

THEATRE PRODUCTS 2008 AW "CYNDI"

The middle book (upside down, readable by rotating):

200 RUTH FIELDING AT LIGHTHOUSE POINT

to advance Nita's fate to the West, if the girl would return.

But up on the gallery in front of the shining lantern of the lighthouse there—"
"No, no!" said Jo as it would be too sad," said Cameron, talk seriously to the runaway.

"I don't know," said Mother Purling; "I like to see comp'ny, too, I do," growled the man.

They came down after an hour, wind-blown, the taste of salt on their lips, and delighted with the view. They watched the ugly, hairy man sitting on the doorstep, listening with a scowl at the yarn of last night's storm—a wondrous tale of winding waves, still riding sail of the lightship on No Man's Shoal.

"She had recovered her breath after the places she had puffed like a steam tower—the smoke of interest to Wes—" green lawns and clumps of windblown trees, long strip of winding coast southward to the east, over the rushing waves, sil- bon laid down for the sea to wash, Fuller's Island, with its white sand beaches— out on the swell of southwest— dared that she reached this point, when she had paffed like a steam— talk seriously to the runaway.

Facing page:

CRAB OF THE HARDSHELL VARIETY 201

"Well, these girls ain't your comp'ny," re- turned the old woman. "Now git up and be off. Get out of the way."

Crab rose, mainly enough, but his sharp eyes sought Nita, looked her all over, as though to make sure that he had never before seen the— "Huge object that he had seen before," she returned, hotly. "I got no folks around here; hev ye?" she asked, "no kin bringing folks around here; hev ye?"

"Your name?"
"Tom!" retorted Mercy, breaking in. "And she lives in the lane, Hardshell? There now! do numbers cucumber! There now! do all you want to know," growled something under his breath and went off in a huffing way.

"That's a bad man," said Mercy, with confi- dence. "And he's much interested in you, Miss Nita Anonymous. Do you know why?"
"I'm sure I don't," replied Nita, laughing quite as sharply as before, but helping the lame girl to the buckboard with kindness.

"You look out for him, then," said Mercy, warningly. "He's a hardshell crab, all right."

藤崎圭一郎　　やさしさを繋ぐクリエーション

それは、使い古された言葉でいえばブランディングと呼ぶのだろう。しかし将来、もっとしっくりくる言葉で言い表わされるかもしれない──。

そもそもブランディングとは何なのか。

単純に言えば、ある商品やサービスを他の同種のものから際立たせること。より詳しく説明すれば、依頼主が望むブランドイメージと消費者が実際に描いているイメージとの間のギャップを埋め、ターゲットの消費者が思い描くイメージを依頼主が望むようにコントロールする一連の作業である。語源は「焼印」。放牧した牛に押す、あの痛そうな目印である。

ブランディングのそもそもの意味は、上から目線でわがままでサディスティックものなのだ。好きになってもらいたい人に自分が望んだとおりに愛するよう画策する。わかりやすさが第一と、有無も言わさず熱した焼きごてで自分のものだと印を付ける。キギの仕事にブランディングという言葉がどうもしっくり来ないのは、そのせいかもしれない。力業で思いを届けるのでない。丁寧に思いを分かち合う。

本稿のために筆者は渡邉良重と植原亮輔に話を聞いた。

キギのブランディングは、どこが一般的なブランディングと違うのか？

植原はこう答えた。「自分で言うのもなんですが、僕には宮田さんから受け継いだクライアントへのやさしさがあると思う」。どんなやさしさ？「クライアントの気持ちになってあげることですね」。「宮田さん」とはもちろん、植原と渡邉が2011年まで在籍した広告デザイン会社ドラフトの代表宮田識。筆者は2009年、宮田のインタビューを中心にドラフトのスタッフや外部の仕事のパートナーを取材し、ドラフトの軌跡を追った『デザインするな』を著した。その経験から言うと、「クライアントの気持ちになる」といっても、宮田は決して企業の論理から生まれる「わがまま」にやさしいわけではない。むしろ怒る。ドラフトのクライアントへのやさしさとは、企業の「わがまま」を「やさしさ」に変えようと、徹底的にクライアントと付き合う「やさしさ」である。キギはそれを宮田から受け継いでいる。

そして、やさしさは連鎖する。「仕事をくれた人に喜んでもらえる仕事を返してあげたい。びっくりさせてあげたいとも思っているので、クライアントが望んでいることにもうちょっと足してあげたいという気持ちはいつもあります」と渡邉。かつて『デザインするな』のために取材をした際、植原はこう語っていた。「いい人にいい仕事が来ると僕は思っている。だから、まずいい人にならなきゃいけない」。いい人って？「人に対して手を抜かないことかな」。クライアントへのやさしさが、共に仕事をする人たちへのやさしさへと広がっていく。それらが次に伝えるべき人への「やさしさ」に繋がっていく。植原はこう語る。「シアタープロダクツの仕事など、わりと近くにいる感度の高い人にきちんと伝えることで、その人たちが広げてくれる。そういう仕事が多いんです」。伝えたい人へきちんとデザインの贈り物を渡す。それが連鎖する。やさしさの波紋が広がっていく。

「仕事をくれた人を喜ばせてあげたいという気持ちはもちつつ、私たちなりの表現は追い求めていきたい」と渡邉。やさしさを分かち合うためにディテールまで丁寧につくりあげたデザインの贈り物たち──。それらが輝きを放つには、つねに新たな表現の可能性を追い求めていかないといけない。表現を磨くことはやさしさを磨くことなのだ。

「依頼仕事だけでなく、自分たちから発信していきたい」と渡邉。「展覧会をしたり、出版をしたり、メーカーをつくったり」と植原。自ら世に問うことで、デザインの贈り物の輝きは増す。

さて、キギの仕事をブランディングと呼ばないなら、どんな言葉をあてようか。まだ未踏の領域だから、勝手に名付けさせてもらう。「オファリング」──もともとは奉納、供物といった宗教的な捧げ物という意味をもつ。転じて、人と人とを繋ぐデザインの贈り物、やさしさを連鎖させるクリエーション。キギの豊かな実りは、デザインに新種の種をはらんでいる。

藤崎圭一郎
1963年横浜市生まれ。デザインジャーナリスト、東京藝術大学デザイン科准教授。1990〜92年『デザインの現場』編集長を務める。1993年より独立。雑誌や新聞にデザイン、建築に関する記事を執筆。ライフワークは「デザインを言葉でいかに表現するか」「メディアプロトタイピング」「創造的覚醒」。著書に広告デザイン会社DRAFTの活動をまとめた『デザインするな』。

立川裕大　　DESIGN FOLLOWS HUMANITY

とにかくファンが多いふたりである。

私の周りにはデザイン業界であるなしにかかわらず、キギのファンが沢山いる。

仕事の領域は広いがどんな作品を前にしても、子どもも大人もワクワクし、ちょっといじわるにアラを探そうとする同業者でさえ気が付けば彼らの世界に取り込まれてしまう。

作者を知らない人でもたいていは作品に好感を持つし、「気にいったものは結果的に彼らの商品なの」などという話もよくあるそうだ。

どうして誰からも好かれるのだろう？

渡邊良重は対象に深い愛情をささげ、感覚を手がかりに独特のタッチで描き進めて行く。まさか魔法の杖を持っている訳ではあるまいが、彼女の手にかかれば、ありふれた話だって味わい深いおとぎ話に変身してしまうのではないかとさえ思う。
希望が見つけにくい今の生活環境の中にあっても、ふんわりとすっかり包まれ、ナイーブな感情を刺激し、日々の生活が色めくようなポエトリーを醸し出し、人生にポジティブさを付けてくれる。
一般の人たちはともかく、プロであっても作品を分析したり批評したりする以前に、渡邊の世界に浸ること自体になんともいえぬ安らぎを覚える。
天賦の才に、濃密な経験が積み重なり、この愛おしくも知的な世界観は彼女の独壇場である。

いっぽうでその和やかなキャラクターから思い違いされることが多いそうだが、実は植原亮輔のアプローチには論理という確固たる軸がある。
本人曰く作品の中には「カラクリ」が随所に盛り込まれている。
線がかすれたり重なったり、手触りが意表を突いたり、そういった緻密に検証された幾つものディテールをともなって作品が構築されているので、最初に見たときの驚きや新鮮さがいつまでたっても失われることなく心に響いてくる。
同業のデザイナーでも、そこに仕込まれた仕掛けを読み解くことは難しいそうだ。
かつてあったデザインをサンプリングしリミックス加工したDJ的（多くの場合は機械生産的）デザインが大量生産されているが、それらは一時の目の保養にはなっても持続性はない。
逆に植原の態度は、人間臭く丁寧に手しごとでクオリティを模索し、「出尽くした」と言われる世にあっても、まだ見ぬ原曲を探求し続けるそれなのである。
原曲には人間を感動させる力がある。

このように、キギはとびきり感覚的な人間性と論理的な人間性によってひとつの体を成しているのである。
それらが刺激し合いブレンドされて作品となる。
人間性が軸にあるからこそ、作品を通じて見る者を捉えて放さず、突出したコミュニケーション能力を発揮する。
そこが皆から好まれる大きな所以なのだろう。

しかし、悲しいかな現在のデザイン界の価値は「人間」よりも「経済」に軸がすげ変わっている。
多くのデザイナーは消費者に向けて手練手管を尽くして刺激的なアイコンを送り出し、次から次へ新しいクライアントを求め続けることに余念がない。
何もかもが消費のためだ。
それとは対照的なキギの態度を思ったときに、イソップ寓話のひとつ「北風と太陽」を連想してしまった。
キギは想いを同じくするクライアントのアイデンティを自らの中に吸収し、人間味に溢れたデザインに変換して拡散し、受け手に想いを分配した結果、仕事としても成果を生み、それが循環し続ける。
「北風と太陽」に例えると「太陽」であるが、こうやって言い連ねると、むしろ（「キギ」の）「木」の持つ生態と重なり合ってくる。
自然界の法則に規範を置くことは、これからの仕事を考えるうえで理想のモデルだと私には思えてならない。

植原は札幌の学生時代に見た一枚のポスターで自らの進路を決めたという。
ドラフト時代の渡邊が担当した仕事がそれであった。
そのふたりが共同でキギを設立することになろうとは、作品を介したコミュニケーションの成り行きとしてはこのうえない話である。
ファンのひとりとしても、新しいステージに立ったふたりのこれからの仕事を期待して止まない。

立川裕大
1965年長崎県生まれ。デザインディレクター、株式会社t.c.k.w代表。企業などの外部ブレーンとしてデザイン戦略を全般的にサポートする。単にモノを生み出すだけにとどまらず、地域活性、人づくりなど社会的課題にも積極的に取り組む。日本の伝統技術とデザインを結びつけオートクチュールの家具やアートワークを制作する「ubushina」を自社でプロデュース。NPOの地域職人では東日本大震災復興支援プロジェクト「F+」を主導する。

植原亮輔インタビュー　インタビュアー 山口博之

**クリエイティブの象徴としての"木"
社名キギについて**

——ドラフトから独立され、渡邉良重さんとキギ（＝木々）という会社を作られましたが、名前にはどんな意味があるのですか。

植原＞　以前あるブランディングの仕事で、アートディレクターの役割を話す機会があったんだ。大きなクライアントで、担当者より上の方たちに我々の存在意義をあまり理解してもらえていなくて、ちゃんと説明をしなくちゃいけなかった（図A）。

僕が説明したのは、ブランドは"木"であり、アートディレクターは"植木職人"だということ。
まずは地面から下を思想哲学、地面から上を社会だとする。土には養分や水分があって、木はそれらを吸い取って育っていくでしょう。それはブランドも一緒で、地面の中にある思想哲学＝知識、教養、技術、想いを吸い上げて、ひとつの幹となってようやく社会に出ていく。
吸い上げ、成長するには根を張らなくてはだめで、好奇心、探究心を持つことによって根っこを強く長く伸ばしていくことができる。地上に出た幹が枝葉に分かれて葉をつけ実を結ぶ。幹はコンセプトであり、実が商品、枝葉は商品を成立させ、際だたせるためのステージやシステム。
地上では突然雨風が吹くことがあるけれど、それはコントロールできない社会的要因で、叱咤激励として受け止めるべきもの。時々射しこむ光は賞賛の光。社会という風に揺られながらすくすくとまっすぐ伸びていくことが、ブランドが成長しているということで、アートディレクターはそうした土や幹や葉や実、または外気の状態を見て管理する植木職人にあたる。ただその植木職人はひとりではなく、クライアント側の担当者も含めたクリエイティブチーム。アートディレクターはその実が赤く熟しておいしいよということを伝えたい。そして伝える先はお猿さん。えっと、普段お客様は神様って言うけど、商品に初めて出会う人という意味でお猿さんに設定してみた（笑）。そのお猿さんに安心して食べてもらうためにビジュアルと言葉で翻訳をするのが、アートディレクターやコピーライターの仕事。
遠くにいるお猿さんには鳥に飛んでいってもらう。これは鳥が広告だったりDMだったりする。おいしい木の実を食べてもらうと、その木が評判になり生命（製品）の良い循環を生む。そういう良い循環を作ることが僕らの大切な役割。
そして良い木が育ったら株分けをして木を増やし、林にする。これは同じコンセプトから派生した商品やお店ができていくことと同じ。
そうしているうちに林はやがて森になっていきます、と、そういうお話をさせてもらったんだ。

——— なるほど。確かにアートディレクターの役割が理解してもらえていないことはありますよね。

植原＞　この話は僕がドラフトに入社して間もなく、宮田さん（ドラフト代表）が、ドラフトの庭で作業をしていた植木職人が木の上から若手に指示する姿を見て、「アートディレクターは植木職人みたいなんだ」と言ったことがきっかけとなっているのかも。数年前、僕がモノづくりに迷っていた時、自分からモノが生まれてくることの構造を理解したくて、"自分が木になって成長していくその根本で水をあげているもう一人の自分"という想像図を描いてみたの（図B）。
描いてみて気づいたのは、自分がモノを生み出す場合、本能のままではなく、ちょっと俯瞰して眺める自分が必要なのではということ。もちろん、本能のまま大きな木を作り上げる天才もいるけど、僕は客観視をしないと真っすぐ木が育たない。
ちなみに水をあげる人間は自分の鏡になる人であれば、自分だけでなく信頼できる"誰か"でもいいと思う。
僕の場合、学生時代までは母親で、会社に入ってからは良重さんだった。リトマス試験紙みたいなもので、きちんとコメントをしてくれる時も、「イエス」「ノー」や「表情」だけでもありがたいんだよ。
さて、前置きが長くなったけど（笑）、社名の「キギ」は木の複数形

（図A）

（図B）

「木々」で、いま話したように、クリエイティブを一本の木と考えて一本ずつ丁寧に育てていき、やがて森にしたいという願いを込めているんだ。

―――― 木は番組やブランドの部署であり、クリエイティブの集積でもあるわけですね。

植原＞　あと、植原という名前は「原っぱに植える人」だし、良重さんは「木々に囲まれて育った」というのもあるんだけどね（笑）。

―――― 先ほどモノづくりの構造についてのお話がありましたが、渡邉さんも同じタイプですか？

植原＞　僕はなぜ作るのか、なぜデザインするのか、いちいち自分の行動について考えるタイプだけど、良重さんは逆で自分が作りたいから作るタイプ。僕はアートディレクターになる以前、早くデザイン力を上げたい、早くアートディレクターになりたい、目立ちたい、賞がほしいという思いが強かった。ところが28歳くらいでそうしたいろいろなことが急に叶ってしまったと勘違いして、結果やりたいことが見つからず頭が変になってしまった。
その時は木を森にしていくという考えがなくて、木を一本作ったらたまたま褒められて、つまらなくなっちゃっていた。
それでどうしたのかというと、ただひたすら考えた。
人間とはどんな条件を持った生物で、何を考え、欲望の行き先はどこで、なんで仕事をするのか、なんでモノをつくらないといけないのか。
その時にやり続けること、木を森にしていくことの凄さに気づいた。良重さんは「継続は力なり」といつも言っていて、頭がおかしくなっていた時にも言われて納得できないと思っていたら、ふと"木"を増やして"森"にしていくというイメージが浮かんで、すんなり理解ができた。つまり、木を植え続けることの苦労を考えたら、これは一生の課題になると思って……。なんだ、まだまだ課題が山積みだったって。
それでこの仕事で生きていくことが逆に楽になったんだよね。
僕と良重さんは、例えるとウサギと亀。なだらかにずっと続く坂を一歩ずつ登っていくのが良重さん。僕は策を練るために止まって、大きくジャンプしてまた止まるという繰り返し。最終的にはウサギである僕が負ける仕組みになってるんだけどね（笑）。
いろいろあった上で今の僕が言いたいのは、とにかく「死ぬな！」ということ。デザイナーやアーティストが健康的に生きる模範になりたい。特に若い人たちの。会社の中に缶詰になり仕事漬けになっていると、内に内に向かってダメになってしまう。良重さんのようにもともと内向的な性格の人はいい。
あるテレビ番組で見たんだけど、内向的というのは心理学的にはとても良いことで、他人がどうであろうと自分の中に絶対的な評価基準を持っているんだそう。例えば明石家さんまさんも実は内向的な人なんだって。僕みたいに他人の目線が気になる人、人の意見を聞いて自分を見つけていくタイプの人は、内側に向かう行動をし続けるのは辛い。もちろん、僕も良重さんの（客観視するための）鏡になっていると思うけど、良重さんは自分でいいと思ったことはなかなか曲げない。僕が絶対コレが正解だよと言っても、結局僕が諦めて、いいんじゃないって言ってしまう（笑）。
だから、内向的ではない僕はできる限りベクトルを外に向けたい。D-BROSの仕事で外の人と関わらず内側ばかり向いていた時、フォーレの仕事を青木むすびさんとやらせてもらって、眠っていた意識が目覚めた。とはいえ、外側の仕事ばかりやっていると社会のからくりに翻弄されることもあるので、内側と外側を呼吸するように出入りすることが健康になるひとつの方法なんだと思う。

アートディレクターという仕事と新しいデザインの可能性

―――― 自分がやっていることを確認したいということですよね。渡邉さんは自分がやっているという事実で確認ができている。植原さんは自分が作ったものを納得して評価してもらって、初めて成立する。

植原＞　仕事をしていくこと、いわゆる職業のひとつの役割は信頼を作って自分をみつけることだと思っていて、生活のためにとか、社会のためにとか、達成感や喜びを得るとかもあるかもしれないけれど、全ての仕事に言えることは信頼を作っていくことだと思う。言い換えれば約束をするということ。
期日やクオリティの約束をして本当に作れると、「作ったよ！」「ありがとう！」という事実が積み上がっていき、仕事を続けると、「できた」「できてない」「その中間」という実績がどんどんできてくる。それぞれが人の形をしているとすると、仕事の実績が重なってくることでその輪郭が濃くなっていく。その結果「できた」の輪郭がはっきりしていたら、幸せな仕事についたということ。自分の良い輪郭（人格）を作れたということだね。これはとてもうまくできた、素晴らしい構造だと思う。
もっと言うと、誰しも目玉はついているけど、自分の顔や姿をそのまま見ることはできないでしょ。極端な話、鏡がない時代は自分を知る方法がなかった。だから人間は根本的に自分を知るためにも他人が必要で、どんな自分なのか言ってもらいたいんじゃないかな。もちろん、恋人や家族を鏡に自分を映すやり方もあるけれど、外部の人とたくさん関わることで自分の輪郭が色濃くなり、社会や時代に染み付くように残ることも大切なんだと思う。

―――― 植原さんは自分の輪郭ができてきたのはいつだと思います？

植原＞　まだまだ輪郭はできてないと思うな。輪郭ができた瞬間

に外そうとする自分がいるし(笑)。新しい輪郭を作らず停滞しちゃう怖さのほうがある。キギをつくる時、これまでやってきた方法論に煮詰まっていたところがあって、プロジェクトをグワッと動かすような、ある意味危険な賭けを提案することができなくなっていた。それは、悪い意味で上手くなっちゃったということだと思うんだけど。だからもっと新しい自分を見つけたいなと思った。

─── 意図的に輪郭を外そうとすると、クライアントが求めているものへの解答として納得してもらえないことはないですか?

植原> クライアントさんが、僕の何を求めているかによるんだけれど、表現だけを求めているクライアントさんにはもしかしたら合わないことがあるかもしれない。でも、考え方やアイデアを求めているクライアントさんの期待には応えられると思う。だから、僕が提案するのは"考え方"だということをできるだけ伝える。表現をプレゼンしたくなくて、考え方のOKをもらいたい。だから最初の打ち合わせの時点でアイデアを話すし、その時点でアイデアに対してOKをもらうことが大事。オリエンテーションを受けて持ち帰ってというのが好きじゃないんだよね。

─── そうした表現と考え方の関係の根底に、共通のロジックのようなものはあるのでしょうか?

植原> クライアントワークではなくD-BROSの話だけど、共通のロジックで表現を変えて作っている例としてカレンダーがある。99年から作り始めて、いつも今までにないカレンダーを作りたいと思ってやっているのだけど、根っこには時間とか瞬間とか状態をテーマにしているような気がする。そのきっかけとなったファッションブランド「MIHARAYASUHIRO」のインビテーション(p106)は、ビリビリに破いて繋いだものをお客さんに届けたいと思い、物質として完全に再現したもの。デザインは、形やレイアウトを詰めに詰めて作るものもあるけれど、行為をそのまま残した状態でもデザインは完成できるんじゃないかって考えた。
03年に制作した「peace and piece」(P164)も、適当にコラージュしたものを裏表で再現できないかと考えてつくったもの。そのコラージュをした時のその状態を再現したかった。「paper jam」(P167)は、カレンダーのデザインとしては普通かむしろダサい。(そのダサいカレンダーを)一度破って不安定な状態でフィックスさせることによって、時間を止める面白さが生まれるんじゃないかなと考えた。
こうしたカレンダー作りを通して、行為をそのまま残すということでデザインができるということがわかった。これは考え方の軸がほぼ同じまま、表現方法のバリエーションで展開しているひとつの例だね。

─── では、アートディレクターはどこを仕事の完成と決めて、達成感はどこで得るのでしょう?

植原> もしかしたら考え方を構築できた時点で、ある程度満足することもあるんじゃないかな。でもアートディレクターの仕事って、達成感を味わえる仕事じゃないかもなと時々思う。
例えば広告は、広告が良くて売れたのか商品が良くて売れたのかわからないことも多そうだし、お祭り騒ぎを起こすこともこの仕事にはついてまわるので、村のお祭りのように終わったらさっさと片付けるような性質も持っていると思う。「今年のお祭りは終わったよ。はい、次!」みたいな(笑)。
だから達成感を味わうというよりは、制作している時が一番楽しい仕事なんじゃないかな。

これからのデザイナー像とすべてを包括する方程式

─── ここ何年かよく聞くようになった、自分で作った野菜を食べることや田舎で自然のサイクルと共に生きることも、身の丈以上を求めてしまう都市での生活に実感を得られないことの反動なのかなとも思うんです。身体性を超えたところで、広告、デザイン業界はイメージをひたすら作り続けていきます。それはすごく楽しいことではあるけれども、ある意味では虚しい部分もあったりしませんか?

植原> すごい課題だよね、これは。もしかしたら我々は仮想現実世界に生きているということだからね。だから僕も、身体への意識を高めようとこの5年間は頻繁に運動をするようになった。

─── デザイナーとしてより良く生きるという意味でも、ADという職能は環境に左右されずに納得できる道があるものですか。

植原> 結果、イメージを発し続けている僕らの仕事は、アートディレクター=問題解決人という視点で考えると、納得できることがあるのかも。
仕事をしている時は意外にも地に足が着いていると思う。イメージをつくる上でその企業や商品の様々なことに向き合わないといけないからね。
仕事をする環境という側面では、幸せな仕事をするには良い循環の中に自分がいなくてはならない。デザインとして良いものも作る→評価される→仕事が来るみたいな。でもデザインが新しくても、新しすぎて伝わらずに売れないということも当然ある。マスに向けて表現する感覚と、新しいグラフィックデザインを表現する感覚は全然違う。両者の表現感覚は全然違うからいずれにしても問題解決人というように自分を置かないと、自分が何を

したい人なのかわからなくなる変な職業なんだよね。かつては、グラフィックデザイナーとアートディレクターという職業を知らない方には、ロゴやポスター、新聞広告を作っている人と言えばわかりやすかったわけだけど、今やメディアが多様化していって、結果デザインしたのは紙媒体のグラフィックというよりは立体物やイベント、空間デザインとかで、重要なのは考え方そのものだったということも場合によってはある。よりイメージの世界に向かっている。質の良し悪しを気にしなければ、ポスターやロゴはいまや誰もが簡単に作れてしまう。だからアートディレクターという職業の強みは、様々なモノ、コトを繋げて世界観を構築する、大きなイメージを作る人なんじゃないかと思う。

─── お二人の場合、イメージを作るだけの仕事ではなく、消費者、ユーザーとより近くで繋がり、金額に換算できるメーカーでもあるD-BROSやDB in STATIONを並行してやっていることが、バランスを取るうえで役立っていそうですね。

植原＞ うん。マクロとミクロを行き来しているのかもとよく感じる。D-BROSというメーカーのデザイナーの場合、現実との闘いで様々な悪条件を乗り越えていかなくてはいけない。だけど、クライアントワークの場合、問題を抱えているメーカーの方々と同じ気持ちになっても仕方がなくて、プロジェクトの問題点をばっくり掴んで大きな方向を示す必要があると思う。D-BROSの仕事でこだわり抜くクリエイションと、クライアントワークの中で削ぎ落とすクリエイションの両方をやることでバランスは取れている気がするけど、一方で頭の切り替えが上手にできなくて変なところにこだわってしまう時もあるかもしれないな。
話は変わるけど最近思うのは、これからはアートディレクターがどうのこうのという時代ではないということ。すべてのクリエイティブが同じ土俵で闘わなくちゃいけないんだろうなと感じてる。そういう意味では自分はまだ土俵の下だけど、その土俵にどうやって上がろうかと考えているところ。土俵の上には様々な人がいる。敢えてクリエイターを外すと、企業の社長さんや文化人もいればスポーツ選手やお笑いの人もいる。もう今までのクリエイターだけがクリエイトしているわけではない。クリエイションがひとつになろうとしている。だから自分から何かを発信する立場になることが必要だと思う。川永を出版したいという気持ちがその第一歩なのかもしれない。

では、発信するにはどうしたらいいか。木の話をした時に、根っこを伸ばして水分や養分を吸い取って地上（社会）に出ると言ったけど、もうひとつ別の例えで言わせてもらうと……。
木の話よりもっと発信力がある例えなんだけど、太陽はそれ自体に巨大な重力＝Gがかかっているでしょ。重力なのでそのベクトルは内側に向かっていて、その力が満杯になった時、外に向かって"びゅっ〜"とエネルギーを放出する。これはイメージなので、実際の科学的な理論は別にちゃんとあるのかも知れないけど……。でもその結果、太陽さんは地球さんや他の惑星さんたちに恵みの光を与えてくれる。僕も同じようにもっとパワーを貯めないといけない。でも、完全に貯まるのを待っていてはダメで、すこしずつパワーを出しながら内側のパワーを貯める。そうすることで自然と社会に何かを発信できていくんじゃないかなと思ってる。

─── 自分から何かを発信するためにじっくり蓄えている状態ということですね。そうした次のステップに行くために、何か考えていることはありますか？

植原＞ 未来のことなのでとても難しいけど、難しいからこそ、それを紐解く方程式が存在するんじゃないか

塵とガス　　集合　　結合　　拡散　　（図C）

と思う。すべてを包括する方程式があるんじゃないかと。
デザイナーが社会と繋がってうんぬんかんぬんという話は多いので、少し違う視点で話してみたい。
またイメージの話になってしまうんだけど、例えばある星が誕生して消滅するまでのストーリーを時間軸で追ってみると……。たくさんの塵とガスがぶつかりながら結合していき、求心的な動きをして徐々に球体になり、長い時間公転しながら安定する。太陽（恒星）ができていく過程で周りに地球などの惑星ができる。そしていずれ寿命で力尽きる。その時間軸の変化を横から縦にするとこんなカタチになる（図C）。
円錐と円錐がそれぞれの頂点でくっつく形をイメージしてもらいたいんだけど……。僕はこのカタチ、地面を透かして「木」を横から見た時の形と似ているなぁと思う。その形がもしかしたらすべてを包括する方程式で、この考え方が色んなことに当てはまるような気がしてならない。生命の成り立ちを圧縮したカタチで表現したら木のカタチになるんじゃないかと思う。人間の速度感覚と違うけど。円錐から逆円錐、逆円錐から円錐、さらに円錐から逆円錐という構造を繰り返していく（図D）。
宇宙が加速膨張していき、最後は爆発して細かい粒子になるという思考モデルを以前テレビで見て、「あ、考えていたことと似てる」と思った。ここからは僕の想像だけど、爆発した星の粒子はまたお互いにくっついていって、星がたくさんできて、また宇宙ができる。そういう繰り返しの形がすべてに言えることなんじゃないかって。
この構造は例えばこれは会議にも当てはまっちゃう。まずはまっさらな時空間にそれぞれが意見を言い出していくよね。そうすると言葉や思考に関係性が生まれて話が進み、徐々に発言がくっつき合い、一つの考え（＝恒星・幹）に至る。そしてそれがいずれ何かの形（＝光・エネルギー・惑星・実）になって世に散らばっていくわけ。そういう吸収（集合）と拡散の繰り返しなんだよね。この吸収（集合）と拡散が全部に当てはまるんじゃないかというのが核心。ご飯だって、いろんなところから食材が一つのキッチンに集まって料理され、人が食べてうんちとして土に戻り、土から新たな命が生まれ、収穫される。
おそらく森羅万象について言えることなんじゃないかな。そんな想像に明け暮れていたりする。でも最近はこの考え方のおかげで、いろいろと整理ができて迷わず進めるようになった気がするんだ。

─── なるほど。確かにそう考えることができると、構造を直感的に理解できて頭がクリアになりそうです。

植原＞ 僕は科学者じゃないから正確なことはわからないけど、人間はたまたま自分という存在の自覚があるから逆にわからなくなっているだけで、ミクロとマクロで同じ構造──例えば太陽系の構造と原子の構造が同じ構造──をしているとしたら、人間の意識とか行動とか考え方なども同じ構造なのだと思う。
そう考えると、今まで話したこと以外にも発見が多い。少し話は逸れるけど、例えば、自然や生物は全て秩序から無秩序に向かうという「エントロピー増大の法則」があるでしょ。いままさにそういう状況で、人間の意識が飽和や死の状態へと向かっているんじゃないのかな。繋がりたいという思いからコミュニケーションに関わる様々なものが発達して、情報のスピードが増大し、人同士がものすごい速さで繋がっている。
そこで何が起こっているかというと平均化なんだと思う。かつてはわかりやすいレベルの差で料理の得意な人、不得意な人が分かれていた。でもいまはみんなが中くらいにうまくなっている。インターネットで食材の名前を入れて調べると、何を作ればいいかすぐに教えてくれるし、それに習うことでみんなが平均的にうまくなっていくわけ。デザインもそうで、誰しもがある程度のものは作れちゃう。だから飽和状態になって何も起こらなくなる。

（図D）

グレーゾーンにある欲望と気づきのデザイン

─── デザインには欲望を喚起する側面がありますよね。平均化を免れてその人らしい生き方をするにしても、人間は欲望を適度にどこかに向ける必要があって、それが生きることをドライブすることもある。それでは、デザインはなにができるのかというと、より良く生きられるような欲望のドライブをさせられるかどうか、なのかなと思うんです。

植原＞ それはひとえに気づきを与えられるかどうかだね。現状に飽きている状態は不快以外の何の感情も生み出していない状態だと思うから、新しい気づきがあると次の思考に移ることができる。新しいものを生み出すには秩序を壊さないといけない。逆に言うと秩序やルールを知らないと気づきを生み出せない。例えばあるリズム＝秩序を作るというクリエイティブの方法論がある。"パン・パン・パン・パン・パン"と手を叩くリズムがあって、そのリズムの途中に"パパン"

という柏子をいれると、ハッとして変化に気づく。つまり、気づきをつくるにはルールなどの必要性があり、自頭切れりから、あるリズムをつくって理解、共有してもらい、そこからの気づきをつくるのがアートディレクターの仕事でもあると思う。

─── 気づきをもって考えの隙を与える、それが欲望を適度にドライブさせる方法かもしれないですね。もうひとつ気づきというので言うと、D-BROSのコンセプトに「between」という考え方がありますよね。2つのモノゴトの間に存在するもの。それは見えない"間"に気づくことだと思うんです。

植原＞ それには僕なりの理論があるんだ。えーと、これは30歳ぐらいの時に考えたんだけど、白と黒とグレーの話。例えば真ん中に白い丸、その外側が限りなく真っ黒だとするでしょ。これは白が常識で黒が非常識を意味する。世の中は白＝常識と、黒＝非常識だけじゃなくて、その間には無限の階調のグレーゾーンがある。クリエイティブは白＝常識過ぎてもつまらないし、黒＝非常識だと理解されない。そのグレーの部分に幅があったとして、その非常識と常識の間のグレーゾーンにこそクリエイティブがあると思う（図E）。
グレーでも黒の際々にするのか、白側に寄せるのかは目的によっても変わる。アヴァンギャルドなもの、エッジーなものは限りなく黒に近いグレー。そしてグレーを開拓していくと、"開拓されたもの＝世に出たもの"となり、次の段階で世の中の常識＝白に含まれてしまう。それが繰り返されていき、宇宙が膨張しているように白が広がっていく＝同時に黒も延々と広がるという構造論を考えている。クリエイティブ＝グレーであり、「between」の考え方もすべて「between white & black」に言い換えることができるので、D-BROSのコンセプトは「グレーゾーン」であるとも言えるのかも。

─── D-BROSのグレーゾーンについてもう少し聞かせてください。

植原＞ 本来は、限りなく黒に近いグレーゾーンの開拓だったかもしれない。でもいまは完成度をつくることだと思っていて、高い完成度は何かというときれいな球体なわけ。アイデアやコストがとんがっていたりすればそれを抑え、逆にひと回り大きな球に点を増やしていくことでとんがりを丸くしようとする心理が働く。球体にすることは先ほど話した星をつくることと同じ。ブランドをつくることも、星をつくることと同じ。星＝ブランドをつくったら、今度は自転・公転していく、つまり営業をしていかなくてはいけない。D-BROSは今、お店ができたばかりで、まさに営業＝自転・公転をきちんとやっていこうとしているところなんだ。

| 常識 | ○ | ・ | 非常識 |

←クリエイション→ （図

─── D-BROSが回り始めたいま、今度は個人として、キギとしてこれから変わること、変えたいこと、そして変わらないことはなんでしょうか。

植原＞ ドラフトにいた時は、あらゆる制約の中でいかにして自分の能力を引き出すかということだった気がする。それはそれで、アイデアを出す訓練になったと思う。でもこれからは制約は解除され、自分で広げもできるし狭くもできる。だから変わっていくんだと思う。
これからは、もうちょっと今までより世の中をちゃんと見ないといけない。それに、僕らはおそらく少数派向けのデザインを生み出しているタイプなので、今後は少しその範囲を拡げることも必要なのかもしれない。より広いところに株分けをして新しい木を植えていくことが。マスを意識したコミュニケーションや商品開発を僕らのアイデアとデザインで挑戦するのか、まったく逆に、今の木をより大きくして少数派のための価値をもっと育てていくのか。純粋に枝葉を伸ばした先にどんな花が咲き、実を結ぶのかは伸びてみないとわからないけど、植木職人（僕ら）が成長をどの方向に促していくかにかかっているんだよね。そういう意味でも今のキギは、期待、心配、気合い、いろんな想いが合わさり、ごにょごにょと何かがうごめいています。

渡邉良重 インタビュー

渡邉＞　私ね、長生きがしたいの。99歳までは元気で現役で生きていられれば……ね。父が今99歳だからきっと私も長生きできると思うんだ。姉がいるんだけど、子どもがいなくて死ぬ時のことをちらっと心配していたから、わたしが看取ってあげるから大丈夫って話したの（笑）。
「あなたはどうするの？」って言われて、私は見送ることができれば心残りがないから大丈夫って答えたら、変わってるねって。

─── 99歳まで続けられるほど仕事は好きですか？

渡邉＞　この仕事は好き。仕事と趣味が一緒だから、楽しい。例えばインテリアデザイナーの人と仕事をして、持ってきてくれた図面を見ると、私が普段やっているのは仕事だっけといつも思うの。図面をひくのは大変でしょ？計算とか難しいことがあって。私は絵を描いて、そこに文字を載せている。仕事と言っているけど、仕事なのかなって。

─── それはデザイナーとして最初から感じていることですか？

渡邉＞　ドラフトに入って最初の方はほとんど広告のみだから、もう少し仕事っぽかったかな。ずっと絵を描いていたかったのだけど、イラストレーターになれるとか、それで食べていけるとか思っていなかったの。私、地に足がついているから（笑）。
もともと中学校の美術の先生になろうとしたのね。でもそれは、絵を描いている傍らで生徒を見ればいいかくらいの不純な動機だった。私の育ったところは家が17軒しかない、バス停まで山を下って3キロっていうほとんど行き止まりの村だったけど、山口県を離れるつもりもなかったの。高校3年生の時、同級生と一緒にデッサンを習ってみて、美術大学に行くなら東京だとは思ったんだけど、全然上手に描けないし、遠いし、学費も高いだろうしって……。地元の国立大学に行けば親が喜ぶし、美術の先生だったら絵を描いていてもいいのかなって思っていたから。だから先生という職業を甘くみていたんだよね。地元では選択肢がなかったし、男の人ほど給料がもらえないのもわかっていたし、小学生の頃から手に職を持とうと思っていたの。父と母がよくケンカしていて、こんなに喧嘩するなら別れればいいのにと思っていたけど、お母さんは手に職がないから離婚できないんだというのも知っていたから。でも不思議なもので、今は外に出かける時、手をつないで支えあっているんだもの。二人の運命を感じたよ。良かった（笑）。それで、高校3年生になって先生を選んだ。でも大学3年生で教育実習に行って初めて違うって気づいた。生徒の絵を見るでしょ。その見て回る時間がもったいなかったの。その時間、わたしも絵を描いていたかった。そもそも教え方も上手じゃない。それで教育実習の間にデザイナーになろうと決めて、実習のレポートに先生になるのをやめましたと書いて提出したんだ。東京で好きなことをして生きていくためにはデザイナーがいいだろうと結論を出して、その後、筑波大学に研究生で2年間行ったの。

─── デザイナーという職業との出会いは？

渡邉＞　小学校6年生の時に読んだ少女マンガでデザイナーという職業は知っていた。ポスターとか小学校で作るでしょ、それがそのまま仕事になることがあるんだって。その時は知っているだけのちょっと遠い世界だったんだけど、大学3年の秋にふとデザイナーという職業を思い出した。ただ絵を描いても、売買が成立してお金が入ってこなければ、職業ではないじゃない。いつか売れるだろうというアーティストへの未来は遠すぎた（笑）。現実的に考えてみると、デザイナーという仕事しかなかったんだよね。大学に行っている間もデザインの本、永井一正さんとか田中一光さんの本は見ていたから、デザイナーだ、東京だって。
筑波に行ったあと、少し経って1986年に宮田識デザイン事務所に入った。雑誌の「コマーシャル・フォト」に宮田識デザイン事務所の紹介があって、手紙を出そうと思ったの。

─── 面接はどうでした？

渡邉＞　持っていく作品がなくて、持っていったのは2つだけ。ひとつは筑波大学の時に作ったチョコレートのパッケージ。魚の形をしたもので、背骨の骨と骨の間にチョコが並べられているみたいなもの。それと家で暇な時に作っていたポップアップカードをたくさん。それぞれ白い箱に入れて持っていったの。そうしたら宮田さんは白い箱に入れたのがいいねって。それだけ褒められた（笑）。

─── デザイナーという道を歩み始めて、自分のデザイン観は変わっていきましたか。

渡邉＞　全然ないよ。デザインがどういうものかということを考えたこともなかった。宮田識デザイン事務所に面接に行った時、PRGRのポスターを見てカッコイイと思っていて好きだったの。でも自分ではその表現はしないかもしれないと思っていたから、絵は休みの日に描けばいいやって。だから平日と休みを全く分けて、平日はデザインの仕事をして、休みは絵を描くということを並行してやっていた。イラストの仕事もしていたんだよ。雑誌の「太陽」とか「ターザン」とか「ミセス」。いい仕事でしょ。

「太陽」では5pぐらいの連載で"美少年尽くし"っていう男色の話。毎回3p美少年を鉛筆で描いていた。あと、ラコステが雑誌の縦3分の1サイズの広告連載をしていて、ある時先輩の井上里枝さんが次は渡邊さんが描いてみたらって言ってくれたの。カラーの小さいスケールだったから水彩絵具を買って描いた。小学校以来だったな。4誌に掲載する広告で、普通はひとつ描いて後はそれを撮影したポジを入稿するんだけど、そうすると印刷が原画と少し違うの。だから原画を4枚描いていた。今だったら絶対やらない(笑)。当然4枚は出来が違うじゃない。だから好きな雑誌からいいのを順に送ってた。

——— そうすると、イラストレーターとしてご飯をたべることもできたんじゃないですか？

渡邊＞ イラストってデザインに左右されるし、他の人の絵が、デザインがよくないためにいい絵に見えなくてもったいないと思っていた。だからイラストだけじゃだめだなって。デザインも同じくらい好きだったし。

——— デザインは何が好きだったのですか？

渡邊＞ 何だったんだろう。当時は例えばラコステだと、ポロシャツをドンと撮るんだけど、キレイに写真を撮るために厚いスチレンボードを間に入れて、襟は襟芯を貼ってという作業も楽しかった。ドラフトの仕事はトータルでやる仕事が多くて、新聞広告もやるけどクリスマス用のギフトボックスを作りましょう、カードも作りましょうみたいな、グラフィックデザイン寄りの仕事もあった。だからラコステはよかったんだけど、いわゆる広告らしい広告は私には向かないと思ってた。

——— 広告が向かないという感覚は、どこから？

渡邊＞ 自分にとって大きすぎるという感じ。例えば葛西薫さんがやられているような烏龍茶の仕事は好きだったけど、グラフィック的に優しくて美しいものはそんなに多くなかった。男っぽいものが多かったよね。後は、クライアントが大きすぎると自分が表現できるところが何もないという気がしていたのかも。

——— 渡邊さんも植原さんも広告には違和感があった二人だったんですね。

渡邊＞ ラコステで、当時宮田さんはADだったのだけれど、すでにほとんどCD的な感じだった。泊まりがけで一日中話しあって、もう一日はゴルフをするようなクライアントとの打ち合わせ合宿もしていて、そんなに話し合っているのに、一切ビジュアルの話にならないの。例えばラコステのスタッフをどう教育するかとか、そんな話ばっかりしている。それについていけなくて、眠ように寝した(笑)。よくそんな次から次に話すことが思いつくなって感心ばかり。宮田さんのやり方が広告のADだと思っていたから、私にはムリムリと思ったんだけどね。

——— ドラフト的なデザインに自分の表現を落としこむ時、自分の表現との距離はどう擦り合わせてきたのですか？

渡邊＞ 私の最初の7年間は他の仕事もあったけど、メインはずっとラコステ。なんだかラコステの話ばかりだね(笑)。宮田さんは、このポロシャツは商品がいいんだから商品をちゃんと出そうよと、写真を中心にドーンとレイアウトする。だから注力したのはラコステのポロシャツをどう撮るかということ。ある年は畳みました。ある年は広げてキレイに撮りました。わたしが好きな、サイズ違いの二枚を重ねた「父の寸法」というのがあったり、7つのサイズを順番に並べた「32色の聖夜」というのもあった。という感じで、そこには私が自分らしさの表現をしようとする余地はあまりなかったんだよね。いや、それでもあったのかな？カタログはたくさん作っていて、表紙はわりと自由にやれて楽しかった。

——— 渡邊さん自身のデザインは何をすることから始まり、どう進められていくのでしょうか？

渡邊＞ 植さんとの仕事の時は、言葉のキャッチボールから始まることが多い。植さんがぱっと言ったことに私がこうかなと返して、さらに話が進んでいって、すっとアイデアがでる時が多い。私一人に依頼が来る場合は、基本私のイラストありきでのオーダーが多い。

——— デザインと言うよりも、渡邊さんの世界観をというオーダーに近い感覚なのかもしれないですね。

渡邊＞ 私はね、なんでもいいの。デザインは、デザイナーの表現の場ではないってよく言われるよね。それは正論だと思ってわかっているんだけど、私はそこに当てはまらないんだったらデザイナーじゃなくてもいいんだ。私は自分の表現をしたいんだよね。デザイナーじゃなくてもいいし、ましてやアートディレクターじゃなくてもいい……(笑)。ただ作品をどこかに出品する時、役割を書く欄があるの。だから肩書きをつけている。自分の表現がしたくて、それが印刷物になるとデザインと呼ばれるものになる。でも、私の世界観でという依頼なら、依頼してくれた人に100％喜んでもらえるようにしたい。

——— デザイナーは、仕事をしていると自分のロジックみたい

なものができてくる気がするんですね。渡邉さんはそれがなくても、デザインができるということですよね。例えば、アートとデザインの違いはと聞かれたらどうですか？

渡邉＞　違いは、頼んでくれる相手があるかどうかかな。D-BROSは自社製品だから少し違うけど。後は印刷してたくさんできるということかな。アートは基本1点もの。印刷するとたくさんできて、みんなの手に渡りやすい。1点ものでギャラリーに展示されるのも嬉しいけど、そればかりだったら、本が作りたいとかプロダクトもやりたいとか思っただろうな。
とにかく何かを作りたい。自分が持つにしても、だれか気に入ってくれた人が持つにしても、宝物みたいになってくれるのが一番いい。どんなものでも、それがあることでちょっと嬉しくなるようなものを作りたい。そしてそれをたくさん作りたい。

─── 仕事でイラストを他の人に頼むことはあるんですか？

渡邉＞　頼むより自分で描くかな。チャンスがあるなら描きたい。本の装丁を頼まれることもある。絵本作家さんの本の装丁とか。でもね、その絵がきらいとかじゃなくて、人の本を作っている時間がないから断ってきたの。

─── え？

渡邉＞　そう、これはデザイナーの風上にも置けないね。時間がもっとあったらやるよ。ただ時間がないの。時間が倍あったらやる。ある依頼に対してそういうことにしているんですって一度断ってから、基本的にそういうスタンスにしてるの。

─── 割りきって効率良くやるということはないんですね。

渡邉＞　困ったね（笑）。さっき言った宝物もそうなんだけど、夢の中にいるようなものを作りたい。観た人と自分が夢の中にいられるようなもの。例えば、花が好きなんだけど、育てるのが好きとか花の名前を知りたいとかはないのね。そういうことに興味があるわけじゃなくて、花が咲いている場所に行きたい。でもそういう場所にはなかなか行けないし、そういう写真にもなかなか出会えない。だから自分で描くんだと思う。

─── なるほど。自分が思い描いている世界を実現するための絵であり、絵を使ったデザインだと。

渡邉＞　ほんとはそうしたい。

─── そこに言葉は必要ですか。

渡邉＞　言葉は好きなの。自分では書けないんだけど。絵を見るよりも言葉に感動する。音楽もそう。ちょっと難しくなるともうだめだけどね。短くて、グッとくる言葉を探している。好きだから絵本を作る時も、自分じゃない誰かに言葉をお願いしたいの。

─── そうすると、渡邉さんにとってデザインは何のための手段なのでしょうか？

渡邉＞　私は昔から増えていくのが好きなのね。仕事をしていると自分で作ったものもどんどん増えていくじゃない。すごく前だけど、植さんに「デザイナーとしてどうしたいの」と質問されて、「とにかくいっぱい作りたい」と答えたの。でもこれは危険だよね、天変地異があるから。天変地異が来たら、作ったものなんて全部なくなっちゃうじゃない。そうなったらそうなった時の覚悟はしなくちゃね。するよ。でもとりあえず今は作っていっぱい増やしたい。だから長生きをしないといけない。人間の脳みそは数％しか使っていないとかいうでしょ。才能があるけど、興味がない人もいるよね。それはいいんだけど、私はもし何かの才能を持って生まれたのだとしたら、できるだけそれを活かしたいな。そのやり切る一つの方法がたくさん作ることだと思ってる。

─── なるほどここで長生きに繋がるんですね。

渡邉＞　長生きする人に量は敵わない。だから健康に気をつけなきゃいけない。あ、でもこれもデザインの話とはちがうね（笑）。

─── ですね（笑）。オリジナルと複製物に違いを感じていますか？

渡邉＞　私の絵は原画といっても、展示して成立するように描いているわけじゃない。いつも時間がない中でやっていて、一枚絵を描いて途中で失敗したら台なしになってしまうから、スキャンしてレイアウトするように絵を分けて描いていたりする。そうすると失敗が少ないでしょ。いままでそうやってきたんだけど、そうすると原画として成り立たないの。最近はそれが残念に思えてきて、原画として一枚絵で成立する絵も描いていきたいなと思ってる。

─── 断片を組み合わせて描くというのは、レイアウトをするデザイナー的なやり方ですね。

渡邉＞　といっても、それはスケジュールとの関係だからね。例えば週めくりカレンダーは、入稿日を考えるといつまでにこの54枚を描かなきゃいけないと逆算して、一日何枚と決めて描いていく。ラフは描いているけれど全体をきっちり構成せずに

始めて、描きたいところから描いて、ある程度描けたら必ず繋げていき、デザインもしていく。

―――― デザイナーとしてこれまで一番楽しかった仕事は何ですか？

渡邉＞　うーん、決められないな。でも『ブローチ』は今までカレンダーとしてお店に置かれていたものが、本屋さんに置かれるものになって、今までと全然違う人に見てもらえるようになった。最初の絵本だからというのもあるけれど、本っていいなと思った。最近増刷してついに10万部までいったんだ。ある人に『ブローチ』をプレゼントしたら、本の波動がすごく一定だねって言われたの。描いている時の気持ちのブレがない絵で、だから多くの人に受け入れられるんだよって。実際に私って気持ちにブレがないの。落ち込むこともないし、腹が立つことも、イライラしてしょうがないということもない。しかもある年齢になるまで人は皆そういうものだと思っていた。植さんは私のことよくロボットって言うの。淡々と仕事ができるっていう意味も含めてね。もちろん特別な時は別だよ。原発のこととか……。

―――― 絵を描く時もフラットなんですか？

渡邉＞　作業していて誰かに声をかけられても全然平気なの。こころが安定している。植さんは絵を描いているとすごくリラックスできるって言うんだけど、そういうことはあるのかも。ただ、自分が集中しているのかどうかは自分ではわからない。家で描く時だと、ずっとテレビをつけて連続ドラマとかを観ながら描いてるの。番組に感動しつつよ。

―――― え？ 感情は全然フラットじゃなくても描けるんですね（笑）。

渡邉＞　涙を流しながら、手元は淡々と描いているの。音とか映像があったほうが、飽きずに描ける。しかもドラマもおもしろい。だからいろんなドラマ観てるよ。最近はアメリカの……。とはいえ、ある程度何を描くか想定できている絵で、単純な作業が多い時だけどね。

―――― お話を伺っていて、デザインという行為へのこだわりがないというか、特殊というか。

渡邉＞　でも、印刷物になる場合、紙を選ぶことや印刷の方法を選ぶことはとても重要。それもデザインの一つで、自分の絵が生きるも死ぬも紙、レイアウト、印刷次第だから。そういう意味でデザインは重要。

―――― だからアーティストではないんですよね。

渡邉＞　そうだね、デザイナーだね。

―――― アーティストになれるとしたら、どうですか？

渡邉＞　憧れるね（笑）。

―――― アーティストは、自分を見つめて自分と闘ったり、不安や苛立ちみたいなものや社会への憤りだったりを表現欲求にしているみたいなことがよく言われますよね。その良し悪しは抜きにして、最終的にはデザイナーの作品になるにせよ、絵単体として見た場合、どこかにアートとしての認識はあるのでしょうか？

渡邉＞　憤りとか、これを吐き出さなければ生きていけないというものがないから、アーティストではないなとかつて思ったの。私はいつも平常心だからそういう葛藤がない。こんな楽ちんなアーティストはアーティストって呼んでもらえないだろうなって。いまのアーティスト像は必ずしもそういうのではないと思うんだけどね。

―――― 渡邉さんの絵には心理的な葛藤とは違うものがある気がしたんですね。ほとんどに動植物ばかりを描いていることとか。生きているものしか描いていない。

渡邉＞　わからないけど、好きなの。人工物を描くことはなくて、生きているものを描きたい。私は意識していないんだけど、周りの人は私の生まれた土地のことを引き合いに出す。生活すべてが山の風景の中で、もしかしたら原風景として影響があるのかもしれないから否定はできないけど、本当のところはわからない。

―――― 少女のモチーフもすごく多いですよね。

渡邉＞　昔は少年ばっかり描いていたんだよ。透明水彩で絵を描いていたころは少女じゃなくて男の子ばっかり。当時、小学校の同級生は女の子が4人しかいなくて、男の子も少なかった。絵を描いたあと、こんな子と友だちになりたかったなとよく思ってた。最近、女の子の方が多いのは、描くのが楽しいから。髪型とか洋服とかね。

―――― 赤ずきんのモチーフも多いですよね。

渡邉＞　私にとって果物の基本はリンゴで、物語の基本は赤ずきん。そして動物の基本は馬。おじいちゃんの名前が覚馬（かくま）

だったり、生まれたのが馬神という土地だったからかな。虫は蝶だね。

─── どれも、大人や社会／都会というところからは一歩裏側に世界がある感じですよね。

渡邉＞　夢の中を描きたいんだろうね。

─── 夢の中だから、固定化されたものではなくて、生きて動いている動植物みたいなモチーフが選ばれるのかもしれないですね。

渡邉＞　あー、そうだね。風があって揺れるとか。

─── 透けるという考え方もそうだと思うのですが、一枚で世界ができているのではなくて、全体として世界ができてくる感覚があります。

渡邉＞　ミラーとかを使うのも多いしね。ある瞬間に世界がパーッと広がるとか。変化していく世界。

─── 植原さんのモノづくりに見られる、瞬間＝行為を止める感覚と渡邉さんの世界が続いていく感覚。たくさん描きたい、描き続けたいということもそういうことかもしれないですね。植原さんが多層を単層に圧縮するデザインだとしたら、渡邉さんの場合は層を層のまま出すというか、構造を圧縮せずに解放しながら提示する。

渡邉＞　『ブローチ』について、山本容子さんに講談社のブックデザイン賞のコメントで"こだま"のようだと言っていただいたり、永井一史さんには"輪唱"みたいだと言っていただいたんだけど、層があるという感じは近いのかもね。

─── デザインの力って信じたりしますか？

渡邉＞　デザインじゃなくてもいいけどね。

─── 25年勤めたドラフトから独立して、二人で会社を作ったわけですが、キギに対する想いは？

渡邉＞　宮田さんに出会ったのは私にとっては本当に運命的なこと。25年間、ドラフトでのいろいろなことが今の私を作ってくれたのだと思う。それに答えられるようにがんばらなくちゃね。「キギ」。この名前がとても気に入っているの。この間、坂本龍一さんが出演していた「森の生命の交響曲」という番組を観たのね。その中に「樹は立ち上がった水だ」と、竹村真一さんの『宇宙樹』という本からの引用があって、詳しいことはわからなかったのだけれど、その時も「キギ」という名前で嬉しいと思ったの。大きな存在としての木。木は枝を広げて葉を茂らせ、酸素を生む。果実でその他の生物を養い、木陰を作って他の木を育て、やがて自分が朽ちて栄養となって土に吸収されていく。そういう命の循環のような、地球を作るものが木であるということ。本当はもっと奥が深いんだろうね……。

─── これから変わっていくこと、変わらないことは？

渡邉＞　好きな言葉がいろいろあるの。ひとつはマイケル・ジャクソンのCDのライナーノーツにあった音楽評論家ネルソン・ジョージの言葉。「ひとりのアーティストのキャリアを推し量る唯一の道理に叶った基準は、短期間のうちに放ったヒット曲の数ではなく、世間の音楽的嗜好や時代が求める流行の変遷に屈することなく、長年をかけて構築された一連の作品にある。永続する偉大さとは、2年、いや、5年でも当てはまらないことは明白であり、やはり10年か20年といった長い年月にわたって活躍し続けてこそのものだ。……そのアーティストの人生の記録となるのだ」。もう一つ、絵本作家のゴフスタインの一冊一冊の絵本にはとても共感する言葉がある。例えば『おばあちゃんのはこぶね』は、小さいころお父さんに箱舟を作ってもらった女の子が大きくなって、結婚して子どもが生まれて、大切にしてきた箱舟とおばあちゃんになった自分だけが残る。「みんないなくなってしまったいま、はこぶねはおもいでいっぱい。／よろこびとかなしみはにじのよう、／それがわたしをあたためてくれるおひさまのように。」とあるの。かなしみもわたしを温めてくれるという言葉はもう悟りの域だね。そうなれたら一生は大成功だ（笑）。そうなりたいね。

A Creation of Kindness
Keiichiro Fujisaki

To use a clichéd term, we would call it 'branding.' But perhaps in the future there will be a more fitting term to use. After all, what, exactly, is branding?

The simple explanation is that it is a way of making a product or service stand out from other such goods. But more specifically, branding's role is to close the gap between the brand image a business desires and the image a consumer holds in their head, thus allowing the business to control the way in which their target demographic sees them. At its root, the word brand means to leave a mark, much like the painful one pressed into the side of grazing cattle.

Essentially, this implies that branding is a sadistic and selfish act carried out from a position of superiority. It is like a love potion used to control the affections of others. Put simply, it is like the act of using hot iron to brand a creature as your own, with or without that creature's consent. And perhaps that is the reason that the word 'branding' does not seem to fit the work done at Kigi. At Kigi they do not strong-arm others into thinking or feeling as they wish, but instead work respectfully towards sharing in a sentiment together.

While writing this essay, I had many questions to ask Uehara and Watanabe directly. For instance, how is branding at Kigi different from other branding work?

Uehara answered that, "If I can so say so myself, I think there's a feeling of kindness towards the clients which we have inherited from Satoru Miyata."

What do they mean by kindness? "We let ourselves share in our client's feelings."

Satoru Miyata, of course, is the leader designer at the advertising firm, DRAFT, where Uehara and Watanabe continued to serve until 2011. In 2009 I wrote a book which traced the path of DRAFT Co., Ltd. Entitled Don't Design (Dezain Suru Na), it focused on an interview with Miyata and included information on DRAFT staff members and business partners. Uehara mentions "sharing in the client's feelings," but using the experience of writing this book as my basis, I would venture to say that this does not mean that Miyata showed tolerance towards the type of selfishness I mentioned before, which is often found in business. In fact, I would say that this selfishness angers him. This kindness shown to clients at DRAFT moves on a deeper level, by transforming the 'selfishness' of business instead into 'kindness.' It is that kindness which Kigi has inherited from Satoru Miyata.

Kindness begets kindness. "When people request work from us I want to give them back something that will make them happy. I also want to surprise them as well, so I always want to give them a little more than they expected." says Watanabe.

Also, when I was interviewing him in order to write Don't Design, Uehara said that "I think that good work comes from good people. Then, in response, we have to become better people than we are." What does he mean by 'good people'? "I guess good people are those who are willing to carry through for others."

The kindness shown to clients also becomes a kindness shown to co-workers, and a kindness towards the person whom the message is intended for. Uehara says, "In the case of my work for Theatre Products, we first spread the message to people who were very close to us, people of high sensibility, and through them the message spread outwards from there. A lot of our work is done like that." So to those they wish to reach, they give a present of design. And that message begets another. It is a wave of kindness spreading ever outwards.

"While we want to make our clients happy, we also want to pursue an expression characteristic of who we are," says Watanabe. With careful attention to detail they create presents of design, made in order to share in these feelings of kindness. To make these presents sparkle and shine, it is ever necessary to pursue the possibility of new forms of expression when creating them. To polish this expression is to polish the feeling of kindness.

"We don't only want to create works for clients," says Watanabe, "but also to transmit things ourselves."

"By exhibiting, publishing and creating manufacturers," adds Uehara. By questioning the world, they increase the shine given off by these presents of design.

But if we can't call the work done at Kigi as branding, what sort of word can we use? As this is still untrodden territory, I will suggest my own idea. "Offering." A something given spiritually. A creation of kindness. For in the rich fruit hanging from the trees of Kigi lie the seeds of a new design.

Keiichiro Fujisaki
B. 1963, Yokohama City. Design Journalist / Tokyo University of the Arts, Design Department, Associate Professor. Head editor for Designers' Workshop (Dezain no Genba) from 1990-92. Independent since 1993, he writes articles related to design and architecture for magazines, newspapers etc. His life-work is to investigate 'just how far design can be expressed through words,' "media type plotting," and "creative awakening." The history of ad design firm DRAFT Co., Ltd. is summarized in his book, Don't Design (Dezain Suru Na).

DESIGN FOLLOWS HUMANITY
Yudai Tachikawa

One thing that is certain is that these two have many fans. I, myself, know many people who, whether in the design industry or not, are big admirers of Kigi. Though their work covers a very large ground, no matter the piece, it never fails to delight children and adults alike. Even rival designers who, perhaps a little mean-spiritedly, might start off by searching for flaws in their work usually find themselves wrapped up, before they know it, in the world which these two create. Even those unfamiliar with the two usually take a liking to what they see. And you'll often hear them say later, "It turns out all these favorites of mine were Kigi products." But why is it that the two appeal so universally to everyone?

Holding a deep affection for her object, and with her fingers on the heartbeat of sentiment, Yoshie Watanabe traces her drawings with a unique touch. Though she does not hold a real magic wand, it seems to me that in her hands the most commonplace of stories transform before our eyes into opulent fairy-tales. Even in our current social environment, where hope can sometimes be hard to find, her works can instill us with a feelings forgotten in adulthood, vibrant poetry offered from everyday life which paints existence positively. And it's not only laypeople who are affected in this way. Professionals who come to dissect or review her work will find themselves filled with a sense of tranquility as they become immersed in Watanabe's world. Combining immense natural talent with a rich accumulation of experience, this endearing and intelligent world of Watanabe's truly is her playground.

On the other hand, while this gentleness of character may lead to misunderstandings, in Ryosuke Uehara's approach we can find that firm axis which is called logic. In fact, according to Uehara himself, his work is filled with 'mechanisms.' A close inspection of these works show them to be constructed with layers stacked upon layers, and brushing against each other to create an unpredictable texture. For this reason, the impression of freshness and wonder felt upon first seeing them will remain indefinitely. Even for fellow designers, deconstructing and interpreting these nuances can be difficult. Often we see mass-produced designs (usually created through the use of machinery) in which, like industrial DJs, old works are simply sampled and remixed. However, even if these designs excite us temporarily, they will lack durability. In contrast, Uehara's approach is entirely human, carefully exploring hand quality work, and continuing to search for new, original melodies despite the many voices which cry out that originality is no longer possible. In Uehara's design lies the power to move the human heart.

Together, as Kigi, these two form a single body possessed both of exceptional human sensibility and human logic. In their works, these two qualities stimulate and feed each other. It is this axis of humanity which allows them, through the works, to project and to communicate, grasping the viewer firmly with their art. This, perhaps, is one of the reasons that so many people love them.

However, the sad fact is that in the present-day world of design, value is more closely associated with the 'economic' axis rather than the 'human' one. A great many designers focus on creating exciting icons made to coax the consumer with trickery and guile, always searching for the next new client rather than the next new idea. Everything with them is driven by consumption. When considering the very different approach of Kigi, I am reminded of the Aesop fable, "The North Wind and the Sun." For when Kigi finds a like-minded client they make that client's identity into their own, translating it into a design full of human kindness, and scattering it so that the feeling is disseminated among those who receive it. As a result, their work bears fruit, and the cycle is carried on. Within "The North Wind and the Sun," they would, of course, be the sun. But one could also say, like their namesake, Kigi ('Trees'), that there is something similar here to the ecology of a tree. I can't help but feel, in future work, that the ideal method must be to model oneself after the laws of nature.

Uehara was a student in Sapporo when, inspired by a certain painting, he chose his path through life. That poster was the responsibility of Watanabe, who was working for DRAFT, Co., Ltd. As for their joint creation of Kigi, nothing in this world could be better for the continued development of their communication and its effects upon their work. As a fan myself, I wait with great anticipation to see what they will produce in the future upon this new stage.

Yudai Tachikawa
B. 1965, Nagasaki Pref. Yudai Tachikawa is director of design and representative officer at t.c.k.w. Inc., where he offers total support as the brain behind a business's design strategies. Not content only with creating goods, he is also proactively involved in social issues such as regional revitalization and human resource creation. He is responsible for producing 'ubushina,' an in-house project of t.c.k.w which fuses traditional Japanese crafts with contemporary design through the creation of haute couture furniture and artworks. He also spearheads the Tohoku earthquake reconstruction project, "F+", for the NPO 'Chikyu Shokunin' ('Global Craftsmen').

An Interview with Ryosuke Uehara
Interviewer Hiroyuki Yamaguchi

- The Inspiration Behind the Name Kigi ('Trees') -

——— *After leaving DRAFT, you and Yoshie Watanabe created a company called Kigi ('Trees'). Why did you choose that name?*

R.Uehara Previously, while working on branding, I had the opportunity to discuss what the role of an art director is. It was a big client and someone, not the person in charge of the project but someone higher up, was having trouble understanding our purpose, and I needed to explain our role very carefully. (fig. A)

I told him that a brand is a 'tree,' and art directors are the gardeners.

What is beneath the earth could be thought of as the philosophy, and above the earth the social. In order to create a brand the roots must be planted firmly, and in order for a brand to exist in society we must each hold on to that philosophy.

The earth contains nourishment, and moisture, which a tree absorbs in order to grow. In the same manner, a brand must absorb the knowledge, culture, craft and imagination found within its earth to grow into a single trunk and appear out in society. If a brand is to absorb these elements and grow it must put down roots. Through curiosity and inquiry the roots can grow strong and extend far. Above ground, the trunk splits into branch, sprouts leaves, and bears fruit. If the trunk is the concept and the fruit the products, the branches are the system and stage which allows the products to excel.

Above ground, wind and rain can come suddenly. Likewise, these are social factors outside our control which must be driven off with strong encouragement. Occasionally sunlight hits us in the form of praise. A tree which grows proud and tall, leaves rustling in the wind of society, is like a brand which grows and matures. An art director is a gardener who checks the earth, the trunk, the leaves and the fruit, and cares for the tree. Of course the art director is not the only gardener who cares for the tree. He works together, as a creative team, with the person in charge on the client's side. One of the art director's jobs is to let the monkeys nearby know how delicious and ripe the fruit is.

I know that usually the customer is God, but in this case, since I'm referring to people who are meeting the product for the first time, I chose monkey instead (laugh). When a brand, or tree, appears in society for the first time, people aren't sure if its fruit is safe to eat. It is the job of the art director and copy writer to let the other monkeys know, through words and visuals, that all is well and they can eat the fruit.

If the monkeys are far away we may have to send a bird, birds being things like adverts or direct mailings. If we can get them to eat the tree's delicious fruit, its reputation will grow and a positive cycle will begin. It is our work to create that positive cycle.

Once a healthy tree has been raised, we can divide the roots, increase the trees, and create a grove. This is like the creation of product derivations and new stores from a single concept. Before long, that grove can grow into a great forest.

Yamaguchi I see. I do think it's true that many people don't understand what an art director does.

I think that analogy first occurred to me a little after I entered DRAFT. A gardener was atop a tree in the company garden giving directions to a younger worker when Satoru Miyata (representative) remarked that, "an art director is a lot like a gardener." A few years ago, when I was hesitating about getting into manufacturing, I don't know if those words were still inside me somewhere, but in order to envision the process by which I could create products from myself I drew an imaginary diagram I entitled "When I Become a Tree and Begin to Grow, Another Me Will Water the Roots. "(fig. B)

If I was going to produce things, I couldn't do it by instinct. I would need to be able to look down from a slightly higher view. I know there are probably talented people who could produce a magnificent tree purely by instinct, but in my case I would need an objective point of view in order to raise a tall, straight tree.

It didn't have to be only myself who waters the tree however, as long as it was someone who I could trust, as a mirror of myself.

Up until college I always used my mother, and afterwards Yoshie, as a sort of litmus test, relying on their comments, their 'yes,' 'no,' or even just their facial expression.

To finally get back to the original question (laugh). Kigi ('Trees') is the plural form of tree. The idea behind our name is to imagine creativity as a single tree, and add to that our desire to raise each tree carefully until we have a forest.

——— *So the tree is not only a symbol of society and branding, but also of creativity.*

R.Uehara There's also the fact that my name, Uehara, means a person who tends fields, while Yoshie can mean a person who is raised among trees.

——— *A moment ago you talked about your process for manufacturing. Do you think that Yoshie works in a similar way?*

R.Uehara I tend to think about why I want to create, why design, and dissect each of my steps, while Yoshie just jumps in and creates because that's what she wants to do.

Before I became an art director I was always in a hurry to become better at design, and to make art director as soon as possible. I wanted very much to stand out and win prizes. Then at 28 it seemed as if a lot of my ambitions had suddenly come true. I don't know if it was because I was too fulfilled, or if it was because I didn't know what to do next, but I went a little crazy.

At that time I wasn't thinking of turning my one tree into a forest.

I had made my little tree, occasionally someone praised me for it, and it was so satisfying that it drove me nuts. I even went to the hospital where they gave me medicine, but I decided to get better without taking it. A year later I was. What I did during that time was to think long and hard.

About what it meant to be human, the way we think, and where our goals lie. Why

to work, and why I should create things.

It was during that time that I realized what an amazing thing it would be to turn a tree into a forest. Yoshie often says that perseverance makes you stronger. While I was still feeling crazy I didn't really understand what she meant, but when the idea of turning a 'tree' into a 'forest' occurred, I felt as if I was hit with a glimmer of understanding. After all, the work of planting and tending trees is a lifelong challenge. There were still plenty of challenges for me to face! And to go on facing them is what would make life fun. Yoshie and I are like the tortoise and the hare. Yoshie climbs the hill quietly and steadily, step by step. I stop to consider my plans, make a huge leap, stop again, and start the whole process over. Of course, as the hare, my way is the losing one in the end.

After having gone through so much, the one thing I want to say is, "Don't give up!" I really hope I can become a model for how to live healthily for other designers and artists, especially for young ones. If you let yourself become canned up at the office and pickled in work, you'll just grow introverted and self-absorbed. It's fine, of course, to be introverted by nature, like Yoshie is.

According to a television show I saw once, introverted people tend to have their own firm compass of judgment, independent of what anyone else might think. For instance, apparently Sanma Akashiya is also a very introverted person. But for people like me, who worry about what others will think of something when they create, and who listen to other people's opinions in order to find themselves, letting yourself turn too far inwards while you work can be hazardous. While Yoshie does use me as her own mirror (in order to gain an objective point of view), she's not the type who can be swayed when she knows she's right. Even if I tell her an idea is just too far out there, in the end she gets fed up and tells me, 'It's fine!'.

However, since I'm not introverted, I try as far as possible to keep a vector directed outwards.

When I was working on D-BROS, not interacting with others, and being entirely introverted, being approached by Musubi Aoki about Laforet was like a wake-up call to my sleeping consciousness. But performing only extroverted, outside work can also lead to one's being tossed about by the machinery of society, so I think one way of maintaining good health is to let the internal and external work and breath together.

- Working as an Art Director and New Possibilities in Design -

——— So you're talking about validation for what you do. Yoshie is validated simply by the fact of doing it. But when you make something, it's not complete until it's understood and appreciated by others.

R.Uehara I think that when we work, the process by which we build up trust in the single role of what we call our profession, is part of the way in which we find ourselves. Whether we do it for our own sakes, or for society, of course there's a sense of satisfaction or happiness we can attain, but I think that all work is a form of building trust.

To put it another way, we make promises. We make promises about deadlines or quality. If we meet those demands we say, "Here you are!" the other side says, "Thank you!" and a reality begins to pile up. As work continues, so do the 'here you are's, the 'not yet's, and the 'its on its way's. If we think of these things as making up a person, the more actual results we see the clearer that person's outline comes into focus. If that person's outline is clearly made out of 'here you are's, then that person becomes someone capable. That person has done well for themselves. They've made a good outline, or personality.

I think this is a wonderful, very well made system.

To put it another way, everyone, myself included, has eyes of their own. Yet we can't see our own face or appearance directly, can we? If you want to take things to an extreme, you could say that before there were mirrors there was no way for a person to know themselves. For humans, in order to fundamentally understand one's self, others are necessary in order to tell us what type of person we are. Obviously, we can also use our sweethearts or family members as mirrors to see ourselves in, but our outline grows clearest when we use many others who are unrelated to us, and at the same time we can leave a mark behind on our society and generation.

——— When do you think you succeeded in creating your own outline?

R.Uehara I don't think I have yet! To be honest, the moment my outline forms I tend to shy away from it. I'm more scared of not creating a new outline and then stagnating. When we created Kigi, in some ways I had really been pared down to the methodologies I had used previously, and was unable to propose making big changes to projects or taking risks. I suppose I had grown good at what I do, but in a negative sense. So I always want to keep searching for a new me.

——— If you intentionally shy away from your outline, isn't there a danger that the client won't be satisfied with the solutions you offer them?

R.Uehara It depends on what the client expects from me. If they're looking for a certain kind of expression then they might be disappointed. But if they're looking for an idea or a way of thinking then I think that I will answer their expectation.

Which is why I try to make it clear as possible that what I propose to the client is a way of thinking. During presentations, I try not to just put forth an expression, but instead to receive the client's okay on a process and way of thinking. It's important on the first meeting to talk about ideas, and to get the go ahead from there. I hate to do an orientation and just go home from there.

——— But is there a base logic at the root of what you do?

R.Uehara This example is from D-BROS, not for a client, but a good illustration of our turning a single way of thinking into a new expression is our calendar. We began making calendars in 1999. Our goal has always been to try and make a calendar different form the types which have existed before, but as a base criterion I think our themes have always been the condition of time and space. The calendars were also our impetus when designing the invitation for fashion brand MIHARAYASUHIRO (p.106-107), where we wanted to deliver something to their guests which was roughly shredded then joined together, in order to completely reinvigorate the piece as a substance. Of course, design can be done by packaging form and layout, but we felt like design might also be possible by leaving behind the traces of the process as they are. For instance, you often see calendars where the tops are glued together so that the pages can be flipped through quickly.

With our "peace and piece" calendar (p.164-165), however, which was created in 2003, we wanted to see if we could make it as a free collage on both the front and reverse sides. With the "paperjam" calendar (p.167), meanwhile, we started with a comparatively less sophisticated calendar design. We then took that design and ripped it up, and by reaffixing it an instable manner gave the interesting impression of time being stopped.

By creating these calendars, we learned what it meant to design by leaving behind the physical traces. And while the axis of thought behind these calendars is almost identical, their mode of expression and variation is manifold.

——— I see. Perhaps it's possible, then, that you're focusing, on defining a conceptual outline while you shy away from an expressive one. As an art director, how do you decide when a work is finished, and when do you feel a sense of accomplishment?

R.Uehara I guess that at the moment you put together a conceptual thought process there is a certain level of satisfaction. However, I sometimes feel that an art director isn't the kind of job where you get to experience that sense of accomplishment as such. For instance, in advertising it's often hard to judge whether the ad and the product have sold well.

There's also a lot of fuss and celebration attendant to this work, and just like a village festival, once it's over you clean up and move on quickly. "This year's festival is over, time to move on to the next!". Maybe the enjoyable thing about this kind of work isn't a sense of accomplishment so much as the time spend creating and transmitting.

- The Future Image of Design and a Universal Equation -

——— In recent years you often hear about people interested, for instance, in growing their own vegetables or making country cycling rides a part of their everyday life. I wonder if this might be a reaction to living in a city, where everything must be bigger and greater. In advertising and design people are constantly creating new images. Of course there's a level of enjoyment in this, but do you ever feel as if there's a degree of futility in it as well?

R.Uehara Phew, what a question.

I guess it might be that we find ourselves living in a world of virtual realities. In my own case, these past five years I've been trying to exercise more regularly.

——— Maybe a designer's role is to improve the quality of life. But as an art director do you think there's a compelling path to take uninfluenced by your environment?

R.Uehara In our work, which may actually be the propagation of images, if we think of an art director as a problem solver, it may be easier then to understand the

designer's role. When I'm working, I'm actually surprisingly realistic.

After all, in design, besides creating an image, you also have to engage with things like the industry involved and the products. In terms of work environment, if you do the work you're suited to you're bound to find yourself in a good cycle. In this case, generally you make something good, it gets appreciated, then you receive more work. Of course, when you make something to be new, there's a risk that it will be too new for the message to be conveyed and the thing won't sell. Being conscious of expression aimed at the masses and being conscious of expressing a new brand design are very different things. And since they are so different, unless I think of myself, ultimately, as a problem solver, it can become a strange, indecisive profession where a person forgets what they want to do.

In the past, if someone unfamiliar with the profession asked you what a graphic designer or art director does, the easy to understand answer would be that they are people who make logos or posters or newspaper ads, but as a result of the diversification of media design has moved away from a paper medium to focus more on the design of three dimensional objects, events and space. There are even times where a system of thought is the central element. Design is moving closer and closer towards a world of the imagination. Additionally, if you're not picky about the quality, posters and logos can be made easily now by almost anybody. Which is why our strength, in the profession of art director, actually lies in our ability to join various things and events together in order to construct a worldview. In a sense, what we are creating is still a very big image.

——— *Of course, for both of you, your job isn't simply to create images. You also come in closer contact with consumers and users, through D-BROS and DB in station, as a manufacturer dealing with capital. Doesn't that require you to strike a certain balance?*

R.Uehara Right. I feel that part of it is moving back and forth between the macro and micro level. In the case of a designer manufacturer like D-BROS, we often have to fight with reality and overcome adverse conditions. But then, these are the same problems our clients face when we work for them. We just need to seize onto the difficulties in a project and steer ourselves on course. Between the fastidious creative process of D-BROS and the necessity to make compromises during client work I think we strike a good balance, but I suppose occasionally we might grow inflexible and become fixated on something unimportant.

Lately I find myself thinking that we're moving into an age where an art director's role will grow more and more ambivalent. I suppose that all the different creative fields are going to find themselves fighting in the same arena. I'm still in the lower ranks of that arena, but I find myself considering how to move up. In the top ranks we can find many different types of people. If we ignore standard creative types we still have people like company presidents, cultural figures, athletes and entertainment figures. Nowadays, artists are no longer the only ones to produce creatively. The creative is becoming a single thing. Which leaves me in a position where I must transmit of my own volition. My desire to publish this book may be a first step in that direction.

But what is the best way in which to transmit? When we started the interview I talked of a tree spreading its roots, drawing up moisture and nourishment from the earth, and then appearing above ground (in society). To use another analogy … This is something which has a much great power to transmit than a tree, but imagine the sun, which actually holds a stupendous amount of gravity. Since it's gravity, that vector is pulling inwards. But when the strength becomes saturated it zooms outward with energy. Of course, this is just a visualization. I'm sure that the actual scientific explanation is much more complex. But as a result, the sun is able to bless the earth and the other planets with its light. Like the sun, I want to build up even more power. However, it's impossible to simply keep waiting until I've stored up my power completely. I need to radiate that power bit by bit while I continue to store it. But if I do continue storing it up, then in the future I think I should be able to transmit something back to society, naturally.

——— *So you're storing away your energy in order to transmit something back. In that case, if we consider designers up until now as having been strong problem solvers, what sort of role will they pursue hereafter?*

R.Uehara I wonder—and I know, since it's the future, this sounds impossibly difficult—but I wonder if there isn't some sort of equation to interpret it. Some sort of universal equation. I know we've been chatting a lot about the way designers are connected to society, but I liked to look at things from a slightly different point of view. I know this is another analogy, but imagine the story of the birth and collapse of a single planet drawn out upon a time axis.

At first, large masses of rubbish and gas collide and form together, and as they continue moving introspectively they slowly form an orb which after revolving for a long time becomes stable. Thanks to the appearance of this star, the earth and other stars form around it. And then, at some point in its lifespan, it explodes. If we could turn that time axis from horizontal to vertical it would look something like this (fig. C).

A tree of course has a different sense of time than people, but if we were able to compress the course of its life and display it over a short period of time as a form I think we would see something similar to the shape of a tree itself. Imagine, if you will, two cones joined at their peak. If you look sideways at a tree sprouting from the earth at an angle I think it resembles this shape. I can't help but feel that this shape might be a universal equation which can be applied to many things. Cone to inverted cone, inverted cone to cone, again from cone to inverted cone, the same structure over and over again (fig. D). I recently saw a hypothetical model of the universe accelerating and expanding until finally it exploded into minute particles and I thought, yes, that looks like what I was thinking of. The way I saw it, the particles of those exploded stars were joining back together to form great masses of other stars and thus recreate the universe. I think that repeating pattern might apply to everything.

That structure even applies to this meeting. At first the space is clear, and we each come bringing our own opinions, but then a relationship is born between those words and ideas, the conversation continues, and our speech begins to build up into it finally comes together into a single idea (star

/ trunk) Later it would be disseminated out into the world in some form (planets / fruit). It's the same pattern of absorption and diffusion (or collection) repeating. The point is that this absorption and diffusion (collection) applies to everything. Even cooking. Lots of ingredients are gathered together into a kitchen, made into a meal. People eat it, return to the earth as feces, the earth creates new life, and then that life is harvested. And it's possible that this pattern applies to all things in existence. Lately I spend all my time thinking about this. A lot of things have become much clearer to me lately due to this way of thinking, which I feel has allowed me to move forward without hesitation.

——— But I guess it would grow boring if you ever grasp the truth.

R.Uehara But could you really call it truth? Nothing's really played out yet. It's just a lot of arrangement directing how things will play out. There's no guarantee things will proceed smoothly.

——— I see. As someone able to grasp this structure intuitively, being able to look at it that way must help put your mind at ease.

R.Uehara I'm not a scientist so I don't really know what's correct. But I think that sometimes people have trouble understanding precisely because we happen, quite by chance, to be aware of our own existence. If the macro and the micro have the same structure—for instance if the structure of the solar system and an atom is the same—then I think people must be built on that same structure.

For instance, everything in life and nature follows the "law of entropy," doesn't it? Moving from order to chaos. Then isn't it true that human consciousness too is moving towards saturation and death? The desire to connect has led to more and more communication and dispatches, the speed of information has increased, and people are joining together at incredible speeds. There seems to be some kind of equalizing force at work. Previously, people could be divided by some easily understandable level into those who were good cooks and those who weren't. But now everyone is in the middle. If you just search for an ingredient online, it will immediately tell you what you should make. Everyone learns this way, on the same plateau. It's the same in design. Anybody can make things to a certain extent. We're reaching saturation, so something is bound to happen.

- **Desires in the Grey Zone and Designing Awareness** -

——— In a manner of speaking, design is a matter or arousing desire. Even if a person wants to escape from this trend of equalization and live in a style suited to them, individually, to some degree their desires still need an object. That's part of the drive behind living. Don't you think that design could perhaps play a role here, by giving people drives and desire for a better way of life?

senseless

common sense

common sense senseless

← creation →

(E)

R.Uehara That's really a question of whether or not we, in our own small way, can provide awareness. When we're tired of our present conditions, the only thing we can breed is discontent. But with a new awareness we can move on to new ideas. But in order to create a new awareness we have to break the old order. Another way of looking at it is that a new awareness cannot be born if one is ignorant of the old order and rules.

For instance, imagine a creative methodology as a certain rhythm, or order. You clap your hands like so, BamBamBamBamBam, but if in the middle you added another clap, BaBam, people will stop and take notice of the change in rhythm. In order to create awareness it is necessary to create rules. To lead people, to create a rhythm together and understand it, and then from there to create awareness, is the job of an art director.

——— I'm not sure whether providing awareness, or openings in thought, is a method of maintaining desire or if it's not. If we think of another sort of awareness, we might mention the D-BROS concept of 'between. ' To exist between two different thing. I suppose that's really a matter of being aware of that in-between place we can't see.

R.Uehara I have a theory about that. This is something I thought up when I was around 30 years olf I think. You see, it's a matter of black and white and grey. For instance, imagine that in the very center we have a white circle, and then everything surrounding that is pitch blackness. The white portion represents common sense and the black portion irrationality. But the world isn't made up of only white/common sense and black/irrationality. In-between there is a grey zone of countless gradations. If creative work has too much white/common sense it will become boring, too much black/irrationality and it will be impossible to understand (fig. E). If this grey area has its own width and breadth, then I think creativity must exist in the gray zone between common sense and irrationality. Whether we veer close to the black edge or the white will depend on our purpose. Avant-garde art and other edgy works try to get as close to that black brink as possible.

When someone breaks new ground in this gray area, the cultivated area becomes part of this world and at the next stage it is swallowed up by the world's common sense/white portion. As this process repeats itself, we could say that the white portion, along with the black portion outside it, is expanding much like the universe (gray universe fig.). If we think of creativity as grey, then the thought process of 'between' we use at D-BROS is really "between white and black," and we could even think of the D-BROS concept as "the grey zone. "

——— When you started D-BROS, what sort of manufacturing were you pursuing?

R.Uehara For the most part I think we were trying to develop in the grey zone as close as we could get to the black line. But now I think we try to make things which are complete. When I think of something which is complete I think of a beautiful sphere. My feeling is that when ideas and costs begin to taper it's time to take a revolution, on a large sphere, the other way around and make points on the opposite side. Making a sphere is like creating the stars we talked about earlier. And making a brand is also like creating a star. That means that once the brand is made it begins to spin and orbit, so that it's time to begin sales. Since D-BROS has just created its first stores, we're definitely at that point of moving forward with sales and revolutions and orbits.

——— For yourself, and for Kigi, are there any things in the future you think will change, that you would like to change, or which you think won't change?

R.Uehara When I was at DRAFT, I felt as if the point was to see how far I could utilize my own talent from within the bounds of a variety of restrictions. It its own way, I think that this was good training for producing ideas. But now that those restrictions are lifted I can expand and contract on my own. So, of course, I think that things will change. From here on out I think it will be a little more important to take stock of the world at large. And since I'm the type who tends to create designs aimed at the minority, I may have to make a slight shift in that respect as well. In other words, divide the roots and create new trees. Should I challenge myself by creating products and communications with an eye towards the voice of the majority? Or should I go the complete opposite route and work on making my own tree bigger by focusing on the minority and nurturing the value inherent there? If a tree is left to spread its branches on its own, there is no way to tell what type of flowers and fruit it will bear until they actually blossom. But as the gardeners, we at Kigi are guiding the limbs of our trees as they mature, and pointing them in new directions. Which is why the leaves of Kigi, right now, are rustling indistinctly with expectation, worry, determination and more.

An Interview with Yoshie Watanabe

Interviewer Hiroyuki Yamaguchi

Y.Watanabe　I want to live a long time. And I want to remain professionally active until the age of 99. My father is now 99 so I feel pretty confident that I too will live a long life. I have an older sister who has no kids, and when said she was a bit worried about when her time came I told her, "Don't worry, I'll be by your side when you die". She then said, "Well what about you," and when I replied "No problem -- if I'm able to see you off first I'll have no regrets," she retorted with, "You're weird."

―――― *You said you would like to remain professionally active until the age of 99 -- do you like working?*

Y.Watanabe　I like this job. I guess it's because my work and hobby are one in the same. For example, when I work with interior designers and look at the sketches they bring to me I always think that what I'm doing isn't a job. I mean, drawing plans are difficult! Calculations and such are difficult things. I paint pictures and add words to them. I call it a job, but sometimes wonder if it really is.

―――― *Is this something you felt from the very beginning as a designer?*

Y.Watanabe　You start with drafting and since the beginning is only advertising it really was like a job. Originally I wanted to paint pictures but I never imagined I'd be able to become an illustrator or survive by doing it. I'm a realist.
I had initially tried to become a middle school art teacher who, in reality, had an ulterior motive: I figured if while doing my own paintings I looked after the kids it would be all right.

There were only 17 houses where I grew up. Though a near dead-end village with the nearest bus stop three kilometers downhill, I had no intention of leaving Yamaguchi Prefecture. While a third-year high school student I tried learning design for the first time with my fellow classmates. If I was going to go to an art school I thought Tokyo was the place to be, but for starters, I couldn't at all draw well, it was far, and I figured tuition would be expensive. . . I thought if I went to my hometown university my parents would be happy and, were I to become an art teacher, I'd be able to paint. I really underestimated the teaching profession.

In my hometown I had no choice and knew I couldn't earn the same salary as a man. From my elementary school days I thought it best to have a skill. My father and mother often fought, and if they were going to fight that much I thought it would be better for them to split up, but I also knew my mother had no marketable skills and as such could not afford a divorce. But it's strange. When they go outside now they hold hands and support each other. I sensed the fate of two people! It was nice.

So, when I become a third student in high school I decided on teaching. It wasn't until my third year as a university student I went to teaching practice and realized for the first time something was off. You have to look at student's paintings, right? I felt that going around and looking at their work was a waste of time. I too wanted to be painting. First of all, I'm not even good at teaching. So it was during my teaching practice that I decided to become a designer, and in the final submitted report I wrote that I had given up becoming a teacher. I finally came to the conclusion that in order to survive and do what I want to do in Tokyo, a designer would be a good choice. After that I graduated and spent two years as a research student at Tsukuba University.

―――― *What was your first encounter with design?*

Y.Watanabe　I came to know designing as a profession through a manga I read during my sixth year as an elementary school student. In elementary school you make posters and things, and they said that this could become a profession. At that time it was a far-away world I only knew existed -- in the fall of my third year at university I suddenly remembered the designing profession. If you're not making deals and have no money coming in, simply painting pictures is not a profession. The path to becoming an artist was just too far away. Realistically speaking, design was the only choice. Even while I was going to university it was books on design, those by Kazumasa Nagai and Ikko Tanaka, which I was reading. I said to myself, "It's design, it's Tokyo."

After going to Tsukuba and after some time passed I entered Satoru Miyata's design studio. At Miyata's studio I was introduced to the magazine Commercial Photo and decided to send a letter.

―――― *How did the interview go?*

Y.Watanabe　I had no work to bring; I only took two pieces. One was a chocolate wrapper I had created while at Tsukuba. It was in the shape of a fish with the chocolate arranged in the space between the bones of its spine. I also brought numerous pop-up cards I made in my spare time while at home. I put them each in white boxes and brought them in. Mr. Miyata said he liked them in white boxes. That was all that got praised.

―――― *Since starting on the path of a designer, has there been a change in your sense of design?*

Y.Watanabe　Not in the least. I've never even once though about what "design" is. When I went for that interview at Satoru Miyata's studio I saw a poster of PRGR and thought it was cool -- I liked it. But because I didn't think I would express myself in such a way I decided it would be best to paint on my days off. So I absolutely separated weekdays and days off, splitting the two: on weekdays I would do my design job and on my days off, would draw. I also worked as an illustrator! The magazine Taiyō and Tarzan and Misses such. Not a bad gig, eh? It was a five part serialized story about male-male love called "Crazy About Boys." Each issue I would draw three pencil images of young boys.

Additionally, Lacoste used to run a one-third vertical serialized advertisement that appeared at the end of magazines. One day, my senior Mr. Inoue said, "Next why doesn't Ms. Watanabe give it a try?" Because there was a small space for color I purchased a watercolor set and did some painting -- the first time since elementary school. As an advertisement slated to be in four different magazines you would normally draw a single painting and after that submit the positive, but when you do that the print is different from the original painting. So I did four original paintings. There is no way I would do this now. It is only natural that the craftsmanship of the four would be different, right? So I sent them out in the order I liked the magazines the best.

―――― *Then doesn't that mean you were able to survive as an illustrator?*

Y.Watanabe　Well, illustrations are influenced by design, and I felt that other people's art just didn't look good because of poor designing. I thought this was a waste. For this reason I thought being just an illustrator was no good. Plus, I liked designing just as much.

―――― *What was it you liked about designing?*

Y.Watanabe　Good question. . . For example take Lacoste. At that time we would aggressively take pictures of polo shirts. In order to take the pictures as nicely as possible we would insert a thick styrene board so as not to be seen, and proceed to paste the collars of the neck. This type of work was enjoyable.
There were lots of drafting jobs in which the work was quite comprehensive - though I did newspaper advertisements and the such, there were also jobs from graphic design asking for a Christmas gift-box or card making. So, while Lacoste was all right, I didn't feel that so-called "advertisement" was right for me.

―――― *Where did that disdain for advertising come from?*

Y.Watanabe　For me, I felt it was just too big. For example, I liked the work Kaoru Kasai was doing with oolong tea, but there weren't many that were graphically both gentle and attractive. There were a lot of masculine ones. Also, I probably felt that if the client was too big there was no place for me to express myself.

―――― *Both you and Mr. Uehara had a certain discomfort towards advertising.*

Y.Watanabe　At that time Mr. Miyata was AD at Lacoste, but by then it already felt as if he was CD. Staying overnight he would engage in conversation the whole day, having meetings with clients all day over golf. Though he was having such intimate dialogue the talks would never turn to visual content. For example, they'd spend the whole time talking about how to train the Lacoste staff. I wouldn't be able to keep up, get frustrated, and sleep. I really admired how one after another they could think about topics to talk about. Because I thought Mr. Miyata's method of advertising was that of an AD, I felt it was something beyond me.

―――― *When you feel your expression slipping away during a draft-like design how did you manage to bring your expression through such distance?*

Y.Watanabe　Though during my first seven years I held various jobs, Lacoste was the main one. For some reason the conversation is all about Lacoste. Mr. Miyata would say because these polo shirts are good merchandise we should draw out the product -- we should layout the photo in the center with a boom! Given this, what we

focused on most was how we should take photos of these Lacoste polo shirts. One year was folded and one year was spread out and really photographed. There were things I liked such as having something called "My Father's Size" in which different sizes were doubly stacked, as well as something called "32-Colored Holy Night" where seven colors of all different sizes were lined in order. In this type of environment there just really wasn't much room for me to attempt self-expression. Well, now that I think of it, was that the ones? I was making numerous catalogs and it was fun to create covers as I pleased.

——— *How do your designs begin and how are they moved forward?*

Y.Watanabe When working with Mr. Uehara (nicknamed Mr. Ue) we will often times begin by tossing around words. Mr. Ue will suddenly say something and I'll return with something else. From there we will continue the conversation and more often than not an idea will emerge. When a request comes just for me most orders are only for my illustrations.

——— *So that means rather than the design the majority of orders for you are geared closer towards your worldview?*

Y.Watanabe Well, for me, anything is fine. It's often said that design is not the place for a designer's expression. Though I know that and understand it as a sound argument, if I don't fit into that mold then I'm fine with not being a designer. I want to express myself. I'm all right with not being a designer, let alone an artist . . . And still, whenever you display your work there's a place for you to write your role -- and so we have to write a job title. When you have a desire to express yourself and that in turn becomes printed material, it is then referred to as design. But if it's a request for my own worldview, I definitely want the person who placed the order to be 100% satisfied!

——— *I feel as if for designers, when they are doing their own work, something like a personal logic begins to emerge. In your case, even without that, you say you can design, right? For example, what if you are asked the difference between art and design?*

Y.Watanabe I'd say the difference is whether or not there is a requesting party. Since D-BROS produces their own products they're a bit different, though. Also, I'd say the ability to print numerous copies.

As for art, there is basically only one piece. When you print you make tons of copies, making it easy to pass into the hands of all. While I'm glad to have a single piece displayed at a gallery, when that's all there is you think things like "oh, I want to make a book," or "I'd also like to do product design. " At any rate you want to create something. Whether you posses it or someone who has taken a liking to it is in possession of it, for it to become something like a treasure is the absolute best. Whatever it may be I want to create something that people will be happy about. And I want to make a lot of them.

——— *At work do you ever ask other people for illustrations?*

Y.Watanabe Nope. Rather than asking, I'll do it myself. If I have the chance I'd like to paint. Sometimes I'm requested to do bookbinding. Things like bookbinding for the authors of picture books. But I've turned them down. It wasn't because I didn't like their pictures or anything, but rather there was just no time to make other people's books.

——— *Really?*

Y.Watanabe Yup, and so here I can be criticized by other designers. If I had more time I'd do it! It's just that there's no time. If I had double the amount I'd do it. If I turn down a certain request for whatever reason, as a general rule I maintain that position.

——— *There are no seeing things in a business-like manner, doing things in an efficient way.*

Y.Watanabe It's a problem. The treasure I mentioned earlier included -- I want to make something that seems dream-like. Something that makes both you and the people you've seen feel as if you're in the middle of a dream. For example, I like flowers but I don't like raising them and it's not like I want to know their names. I just don't have an interest in it -- I want to go to a place where flowers are in bloom. But I can't really get to such a place, and I don't often have the opportunity to see photos of them. So I paint them on my own.

——— *I see. Pictures make real the world you imagine, and these pictures you use in design.*

Y.Watanabe That's really what I strive to do.

——— *Are words necessary for that?*

Y.Watanabe I like words. But I can't write by myself. More than looking at pictures I am moved by words. The same with music. But if they start to get even a little difficult it's no good. I'm looking for short, powerful language. Even when I create picture books I like to ask people other than myself for words.

——— *If that's the case, then design is a means for what?*

Y.Watanabe From long ago I have always enjoyed the multiplication of things. That which you create yourself gradually increases while you are doing work. This was a long time ago, but one time I was asked by Mr. Ue, "As a designer, what is it you want to do?" I answered, "I just want to produce volumes. " But this is dangerous. If a natural disaster comes all I've created is lost. Were that to happen, for that time, we must mentally prepare. And I will. But for now I want to create a lot and add more to my repertoire.

And this is why I must live a long life. Humans only use a certain percent of their brains, right? If I happen to have to have the ability to draw pictures, I want to use it as much as possible. There are also those people who have the ability but just don't have any interest. That's understandable, but for me, were I born with a certain talent, I would want to utilize it as much as possible. I believe one method of carrying this out is by making large quantities.

——— *I see, so this is where living a long life comes in!*

Y.Watanabe When you're talking about quantities the amount just can't compare with those who live long lives. So I have to be careful about my health. But this too is a bit off topic from our conversation about design.

An Attitude of Painting A Flat Heart & Un-blurred Pictures

——— *Do you feel any difference between originals and reproductions?*

Y.Watanabe Though my pictures are original artworks, I don't paint them to be completed and displayed. Because I'm always working when I don't have any time, if I make a mistake when painting a picture I'm absolutely ruined. So I paint by dividing the picture and scanning different parts as if it were a layout. Doing this I don't have many errors. This is how I've operated up until the present day, and as a result, I don't get many completed "original paintings. " I've recently thought this to be unfortunate, thinking I'd like to complete a painting as an original work of art.

——— *Painting by combing parts - this is designing in a layout-like methodology.*

Y.Watanabe Yes, but it's really an issue of time. For example, when I think about the manuscript schedule for a weekly-calendar I know I have to draw 54 pages, so I calculate backwards how many paintings I have to draw each day. I do draw rough sketches but I begin while I still don't have the whole structure down to a T. I then start drawing from where I want to draw, and after I've had some success I bring them together, also working on the design.

——— *What job did you have the must fun as a designer?*

Y.Watanabe I can't really say. Brooch, which up until now had been placed in stores as a calendar, is now found in bookstores. A completely different audience now has access to it. Maybe because it's my first picture book, I thought, "Wow, it's good as a book. " Recently it's gone into reprint, finally reaching 100,000 copies. When I gave Brooch as a present to someone they say said, "The flow of the book is really uniform. " The sensation of painting pictures with no blurriness -- this is why many people accept it. In reality, I feel no blurriness of emotion. I don't get down and I don't get angry, and I also don't get extremely frustrated. I used to think until you reach a certain age everyone was like that. Mr. Ue often called me a robot. This is in part because I am capable of doing work in an unaffected manner. Of course there are times when this doesn't apply - things like the nuclear reactor. . .

——— *Are you also emotionally flat when painting?*

Y.Watanabe Even if someone talks to me while I'm working I'm absolutely fine. My mind is at ease. When Mr. Ue is drawing he is extremely relaxed - some people are like that. However, for me, I'm not sure if I'm concentrating or not. When I paint at home I keep the TV on, painting while watching serialized dramas, while being

moved by the TV program.

— Oh? Even if your emotions aren't completely flat you can paint (laughter)?

Y.Watanabe Even if I'm crying I can paint what's at hand. When there's music or video it's easier for me paint without losing interest. And plus dramas are interesting. So I'm watching various dramas. Recently it's been American ones. . . That being said, these are paintings I have, to a certain extent, already imagined what I will draw, so most of the time the work being done is rather simple.

— Listening to you talk it seems you aren't bound by design. Or is this your defining characteristic?

Y.Watanabe I'm not really bound, but when things go to print choosing paper and the method by which to print is extremely important. This is an element of the design: the success and failure of your painting depends on the paper, layout, and printing. In that sense design is vital.

— That's not an artist, right?

Y.Watanabe That's right, that's a designer.

— How about in the case of an artist?

Y.Watanabe I definitely romanticize.

— It's often said that artists gaze upon and fight with themselves, striving to express uneasiness and anger, or the resentment they have towards society. The question of right or wrong aside, though the final product may be the work of a designer, when viewed as a final piece does it not have the qualities of such art?

Y.Watanabe Once I thought that because I didn't have something like resentment I had to spew out in order to live I wasn't an artist. Since I always keep a steady heart I don't have that type of struggle. No one would call such an easy-going artist an artist. Though I don't really think the current image of an artist is necessarily that. . .

— I feel as if contained within your paintings is something different from a psychological battle. Things like simply painting plants and animals.

Y.Watanabe I only paint living things. I'm not sure why, but I just like it. I don't draw man-made objects -- I want to draw living things. I don't think this but the people around me usually attribute to the place I was born. All aspects of life were in a mountain landscape, and because there could be influence from this original scenery there is no room for denying it, but the reality is I just don't know.

— There is also the prominent motif of young girls.

Y.Watanabe In the past I only used to paint young boys. When I used to paint in clear watercolors it wasn't young girls but rather young boys. At that time I only had four classmates from elementary school who were girls and only a few boys. After I'd paint a picture I would think, "I want to become this kind of kid's friend. " The reason why recently there are more young girls is because they are more fun to paint. Their hairstyles and western clothes, etc.

— The motif of Little Red Riding Hood is also strong.

Y.Watanabe For me, apple is the basic fruit and Little Red Riding Hood is the basic narrative. And the basic animal is a horse. That's because my grandfather's name was Kakuma and I was born in a place called Umagami -- both contain the Chinese character for horse. And for bugs it's the butterfly.

— It feels as if there is a world one step behind the adult and societal/urban one.

Y.Watanabe I guess I'd like to paint as if in a dream.

— Because it's in a dream that may be the reason living, moving plants and animals are chosen over immobilized objects.

Y.Watanabe Oh, perhaps! Things like there being wind and shaking things.

— I think the concept of being transparent is similar -- it's as if the world is not composed of one page but rather the world comes into being as a whole.

Y.Watanabe I often use mirrors and such. And the world suddenly spreading out in an instant. A changing world.

— An instant as the action of stopping that can be seen in Mr. Uehara's craftsmanship is similar to your feeling that the world continues on. The desire to paint a lot and to continue painting may be somewhat similar. If Mr. Uehara's are designs that compress multilayers into single ones, then you may be presenting layers just the way those layers are. It presents a structure that is compressed while being emancipated.

Y.Watanabe In the Kodansha Book Guide Award comments Yoko Yamamoto said about Brooch that it was like an "echo," and Kazufumi Nagai said it was like "a musical troll. " It's similar to a feeling of having layers.

— Do you believe in the power of design?

Y.Watanabe It doesn't have to be design.

— You and Mr. Uehara branched out and created your own company after working for 25 years at Draft. What thoughts do you have towards Kigi?

Y.Watanabe I honestly think it was fate that caused me to meet Mr. Miyata. I believe the 25 years of various things I did at Draft created who I am now. I have to try hard to answer that question.

"Kigi" (Trees). I really like this name. The other day I saw a show Sakamoto Ryuichi appeared in, called "The Life of The Forest: A Symphony". In it there was a quote by cultural anthropologist Shin'ichi Takemura from his book Space Tree: a tree is water that has stood up. I didn't get all of the details but at that time I was once again happy with the name "Kigi. " A tree as a grand presence. Trees have branches that spread out, are lush with leaves, and produce oxygen. With fruit they nourish other living things, cast shadows and raise other trees, and finally their rotten branches will become nourishment for the soil and be absorbed. It's trees that create the earth through such a cycle of life. I wonder if it's even deeper than that...

— What will, or will not change in the future?

Y.Watanabe There are some quotes I like. One is a quote by music critic George Nelson in the liner notes of a Michael Jackson album."The only logical standard by which one can wrap their head around the career of a single artist is not found in the number of hit songs produced over a short period of time or how that artist yielded to the musical tastes of society or the changes in fashion; it lies in a series of works constructed over many years." It is self-evident that lasting greatness does not mean two or five years; it is that which over the span of ten or twenty remains active. . . It becomes a record of that artists life. "

Others appear in picture books by Goffstein with which I can deeply sympathize. For example, My Noah's Ark is a story about a young girl who in youth had her father carve an ark, grows up, gets married and gives birth to children. And all that remains is that ark she looked after and she herself who has become an old lady. "Now everyone has gone away and the ark is full of memories. / Joy and sorrow is like a rainbow,/ it is like the sun that warms me up. " To say that sadness also warms me is already on the verge of enlightenment. Once that happens life would be a giant success. I'd like to become like that.

Credits by Work - Excluding Ryosuke Uehara and Yoshie Watanabe

CLIENT WORKS & D-BROS PRODUCTS

CREATIVE DIRECTOR
- Satoru Miyata — 1,3,5-6,19B-24,30,62A-B,66-90
- Musubi Aoki — 28-29,64A

DESIGNER
- Aki Ago — 55B,56B,57A
- Akiko Sekimoto — 24A,53
- Aya Iida — 2,9A-9B,10-12,14,15A-B,15D,25-27,48,50-52, 55A,56A,57D,60A,63,83D,87,88A,88G,89-90
- Daisuke Kokubo — 1,11,60B,63,68D,69A,70A,83B
- Kazuya Iwanaga — 4,6,22,24B,25,26C,33,37,42,59A,60A,75,77,78, 79,80A,85A,89-90
- Ken Okamuro — 3,64A-B,83C,
- Mayumi Inoue — 31,37,65,80B-81
- Masashi Tentaku — 16-18,19A,28-29,61A,64A-B,70B,89-90
- Serina Shiota — 7,13,49
- Shoichi Maehara — 62A
- Shoji Katsume — 67,68A,88F,88H
- Takahiro Yasuda — 57C,83A,89-90
- Takuma Fukuzawa — 61B
- Tatsuya Kasai — 54B,71A,82
- Tsuyoshi Hisakado — 5,62A,68B-C,88B,89-90
- Yuka Watanabe — 8,9A,15C,15E-15F,81B,84,86A,88D-E,88I
- NOROSI(Web) — 28B

COPYWRITER, LYLIC
- Asaji Kato — 25-27,64A-B
- Chiaki Kasahara — 22,24,39B
- Mika Kunii — 28-29,89-90
- Naomi Takayama — 37
- Yayako Uchida — 35-36,38-39A,40-41
- Yuhei Nayuki — 62B

PHOTOGRAPHER
- Fumio Doi — 12,15B,15E,60A,65
- Kazuhiro Fujita — 10
- Kenshu Shintsubo — 24A,28B,29A
- Saori Tsuji — 22,64A
- Takehiro Goto — 13
- Tamotsu Fujii — 40-41
- Yasutomo Ebisu — 24B,26A
- Megumu Wada — 62B

ILLUSTRATOR
- Megumi Yoshizane — 25

HAIR MAKE
- Katsuya Kamo — 22,24B,26A
- Mika Kanzaki — 64A
- Yoboon — 65

STYLIST
- Kumiko Iijima — 22,64A
- Miki Aizawa — 13
- Musubi Aoki — 27A
- Setsuko Todoroki — 24A
- Yoko Omori — 65
- Yuriko E — 27A

PRODUCER
- Arisa Kakusue — 38-39A
- Akiko Hino — 4
- Mami Tamura — 62A
- Minako Nakaoka — 1,3-6,19B-24,30,58A,59A,60B,61B,66-90
- Takumi Goto — 16-19A,28-29,60A,61A,65,89-90
- Toshihide Nishio — 25-27,62B
- Yoshitaka Haba — 61A

CREATIVE COORDINATOR
- Kanako Abe — 25-27
- Takumi Goto — 5,67-69A,70B,73,75,77-80A,84,85A,86-88

PRIVATE WORKS

91 WORKSHOP - 9TH MARTCH QUINTET -

LECTURE
Umitaro Abe & Ryosuke Uehara & Yoshie Watanabe

SUPPORT
-Sakado minami elementary school-
Masahisa Ota Nobuo Kaneta Yoshifumi Haito
and, 38 boys and girls.

STAFF
- 'DEMAE ART DAIGAKU' The alumni association of Tama Art University -
Koki Sugawara Atsuko Saito Yoshihiko Mukoda Bozzo Kou Kashiwagi
Noriko Iida Sayaka Mori Kaoru Sato Akika Tamura Yuriko Takimoto
Takami Kobayashi Mikumo Nagamine Kisa Shimura Saori Kusano

ORGANIZER
The alumni association of Tama Art University

92 KAYOJUTSU

ARTIST — Murg Tikka Lawabdhar
(Musubi Aoki & Saori Tsuji & Ryosuke Uehara)

93 BROWN MORSELS OF DESIRE

- ACTOR — Jun Kunimura
 - Michio Akiyama
 - Miwako Ichikawa
 - Peter Martin
 - Akiko Tanno
- CAMERAMAN — Saori Tsuji
- STYLIST — Kumiko Iijima
- HAIR & MAKE-UP — George Morikawa
- CAMERA ASSISTANT — Tomohito Tanaka
- LIGHTING — Yoshito Matsuyama
- VIDEO ENGINEER — Takuya Ishimoto
- PROP MASTER — Shigeto Kawarabuki
- PRODUCTION DESIGNER — Atsuyoshi Edahiro
- CHOCOLATE — Asako Iwayanagi
 - Kiyotaka Sakuraba
 - Yoshitake Kawakami
- SOUND — Umitaro Abe
- EDITOR — Kentaro Ohama
 - Yumi Itakura
- PRODUCTION MANAGER — Shiori Kasai
- ASSISTANT DIRECTOR — Kazuhiro Morikiyo
- PRODUCER — Takumi Goto
 - Yuya Toide
- PRODUCTION — ROBOT COMMUNICATIONS INC.
- DIRECTOR — Ryosuke Uehara & Yoshie Watanabe

94 SPECIMEN OF TIME

- CAMERAMAN — Fumio Doi
- MUSIC — Umitaro Abe
- EDITOR — Miyuki Nagata
- ARTIST — Ryosuke Uehara & Yoshie Watanabe

PHOTOGRAPHER

- Amana — 1,3,8-9,15,17,18C-H,20-21,23,26C,33-41,43, 48,52-54,56A,57A,59,61,62B,63,66, 69A,70-71,73,77-82,83B-D,84-85,87-88
- Fumio Doi — 16,30-31,60A B,65,89A,93B-96
- Keisuke Ono — 28A,90
- Kenshu Shintsubo — 5,67-68,
- Takehiro Goto — 18A-B,29B,42,56B,57B,57D
- Takuo Ota — 89B
- Tamotsu Fuji — 72
- Megumu Wada — 57C,62A,76,83A
- Mikio Hasui — 69B

Special thanks ! DRAFT co.,Ltd.

著者プロフィール

植原亮輔　　　渡邉良重

R. UEHARA　　Y. WATANABE

Y　1961年　山口県生まれ

R　1972年　北海道札幌市生まれ

Y　1984年　山口大学卒業
Y　1986年　10月、ドラフトの前進宮田識デザイン事務所に入社、約7年間ラコステの広告・SP制作に携わる
Y　1987年　ギャラリーハピタにて個展
Y　1989年　8月、HBギャラリーにて個展
Y　1992年　3月、HBギャラリーにて個展
Y　1995年　JAGDA（日本グラフィックデザイナー協会）新人賞受賞
Y　1996年　三木卓氏作・絵本『イヌのヒロシ』（理論社）の装丁・挿絵を手掛ける
Y　1997年　ドラフト内のプロダクトプロジェクト・D-BROSの商品のデザインを始める
　　　　　　D-BROSのカレンダー、'PAPER TALK'で東京ADC賞受賞
　　　　　　池澤夏樹氏作・絵本『世界一しあわせなタバコの木』（絵本館）の装丁・挿絵を手掛ける

R　1997年　多摩美術大学美術学部デザイン科（テキスタイル）卒業後、ドラフト入社
R　1998年　12月、D-BROSに参加

　　　　　　　　　R&Y　1999年　仙台のベーカリーレストラン・CASLONの設立プロジェクトに参加
　　　　　Y　モスバーガーの新聞広告で、東京ADC賞受賞

R　2000年　D-BROSのガムテープ'A PATH TO THE FUTURE'のグラフィックデザインで、東京ADC賞受賞
　　　　　Y　2001年　東京ADC会員に選出される
　　　　　　　　　11月、HBギャラリーにて笠原千昌氏と個展「BUCH」を開催
　　　　　　　　　R&Y　ワコールのアンダーウェアショップ・une nana coolのアートディレクションを始める
R　東京青山にあるスパイラルホールで開催された「竹尾ペーパーショウ」に参加
　　JAGDA（日本グラフィックデザイナー協会）新人賞受賞
　　　　　　　　　R&Y　2002年　銀座ggg（ギンザ・グラフィック・ギャラリー）にて、「ドラフト展」を開催
　　　　　Y　'BUCH'でNY ADC賞・GOLD受賞
　　　　　　　　　東京ADCの展覧会及び年鑑のアートディレクション
R　'ミハラヤスヒロのインビテーション'で、東京ADC賞・YOUNG GUN（豪）金賞受賞
　　　　　　　　　R&Y　2003年　D-BROSのプロダクト、フラワーベース'HOPE FOREVER BLOSSOMING・LINE'
　　　　　　　　　　　　カップアンドソーサー'MIRROR・RIVULETS OF THE HEART'を発表
　　　　　Y　ファッションブランド"HaaT（イッセイミヤケ）"のテキスタイルをコラボレート
R　東京神田の青山見本帖本店にて、「limited展」開催
　　D-BROSのフラワーベース'HOPE FOREVER BLOSSOMING・LINE'で東京ADC賞受賞
　　　　　Y　2004年　内田也哉子氏と絵本『BROOCH』（リトルモア）を出版
R　東京ADC会員に選出される
　　D-BROSのカレンダー'PEACE & PIECE'でNY ADC・GOLD受賞
　　共著『GRAPHIC』（六耀社）の出版に携わる
　　青木むすび氏、辻佐織氏と共にムルグティカラワバハルとしてパフォーマンスアートグループを結成し、
　　ファッション雑誌『流行通信』（インファンス・パブリケーションズ）の連載を始める（全21回）
　　　　　　　　　R&Y　2005年　東京青山にあるスパイラルホールで開催された「竹尾ペーパーショウ」にD-BROSチームとして参加
　　　　　　　　　　　　une nana cool姉妹店・LuncHのアートディレクションを始める
　　　　　Y　絵本『BROOCH』でNY ADC・GOLD受賞
　　　　　　絵本『BROOCH』講談社文化出版賞・ブックデザイン賞受賞
R　ラフォーレ原宿の年間イメージ広告のアートディレクションを担当
　　　　　Y　2006年　絵本『BROOCH』の英語版を出版
　　　　　　『BROOCH』でOne show Design・GOLD受賞
　　　　　　PROPNEREの指輪のパッケージでBritish D&AD・GOLD受賞
R　装丁をした『縷縷日記』（市川実和子氏、東野翠れん氏、eri氏共著・リトルモア）が出版
　　松下電工集合住宅向けバスプロジェクトi-Xのコンセプトカタログのアートディレクションを担当
　　ファッションブランド・シアタープロダクツのアートディレクションをスタート
　　ラフォーレ原宿の年間企業イメージポスター'DECORATION. LAFORET'で、ワルシャワ国際ポスタービエンナーレ銀賞受賞
　　　　　　　　　R&Y　スパイラルホールにて、D-BROSの企画展「GとPのあいだ」を開催

R&Y	2007年	21_21 DESIGN SITEで開催された「チョコレート展」に参加し、ショートフィルムを制作
		東京都現代美術館で開催された「SPACE FOR YOUR FUTURE」に参加し、'時間の標本' を制作、発表
Y		MIKIMOTOのウィンドウディスプレイのアートワークを担当
R		アートディレクション、デザインに携わった『シアタープロダクツのメソッド』(リトルモア) が出版
		札幌スカイホールギャラリーにて「クリエイションとエデュケイションのあいだ展」開催 (まほうの絵ふで主催)
R&Y	2008年	11月、東京・清澄白河にあるAMPGギャラリーにて、'時間の標本' を開催
		10月、宇都宮美術館にてワークショップ「紙の時計を作ろう」を開催
Y		高山なおみ氏と、絵本『UNDEUX』(リトルモア) を出版
		SOFINA beautéのアートディレクションを手掛ける
R		9月、G8ギャラリーにて菊地敦己氏、平林奈緒美氏と「FASHION/GRAPHIC」展を開催
R	2009年	2月、アートディレクションを担当したTokyo's Tokyoの店舗が羽田空港にオープン
		東京ADCの展覧会及び年鑑のアートディレクションを担当
		シアタープロダクツのグラフィックツールで、第十一回亀倉雄策賞、東京TDC賞を受賞
		3月、G8ギャラリーにて「第十一回亀倉雄策賞受賞記念・植原亮輔展」を開催。(後に新潟に巡回)
		4月、凸版印刷主催の展覧会「GRAPHIC TRIAL」に参加
R&Y		3月、銀座gggにて、2度目の「ドラフト展」開催
		9月、アートディレクションを担当したPASS THE BATONの店舗が丸の内ブリックスクエアにオープン
		エルメスのリサーチプロジェクト 'プレシャス・ペーパー' に招待参加
Y	2010年	D-BROSのカレンダー 'ROSE' でOne show Design・GOLD受賞
		イギリス、LIBERTYの2010年秋冬コレクションにテキスタイルデザインを提供
R		「GRAPHIC TRIAL」の為に作成したポスター 'Repetition on surface' でNY ADC・SILVER受賞
		アートディレクションを担当したgredecanaが5月にブランドデビュー、10月北青山に店舗がオープン
		8月、装丁を手掛けた『小泉今日子・原宿百景』(スイッチパブリッシング) が出版される
R&Y		オランダのSENZ®社が開発した傘のテキスタイルをデザインを手掛ける
		PASS THE BATONのグラフィックとHOTEL BUTTERFLYのグラフィックでJAGDA賞を受賞
		VICTORIA AND ALBERT MUSEUM(英)とD-BROSとのコラボレーション企画で'Time Paper for V&A Museum'を制作
		くるみ割り人形、オーケストラ演奏のための映像を制作、映像の素材となるスカーフをデザイン
R&Y	2011年	2月、D-BROSの初の店舗となるDB in STATIONが品川駅構内エキュート品川にオープン
Y		D-BROSのカレンダー '12LETTERS' で 東京ADC会員賞、東京TDC賞受賞、JAGDA賞受賞
R		NY ADCの審査員をつとめる
		ディズニーのプロダクトコンセプトを制作したグラフィック 'Winnie The Pooh!' で、NY ADC・BRONZE受賞
		10月、アートディレクションを担当したFACEの店舗が有楽町ルミネにオープン
		10月、中国のグラフィックのコンペティションGDCの審査員をつとめる。
R&Y	2012年	1月、東京・渋谷区代官山にあるヒルサイドテラスに、キギ Co.,ltd. を設立
		3月、多摩美術大学校友会主催「第41回・出前アート大学」のワークショップを埼玉県坂戸市立南小学校にて開催
		4月、クレマチスの丘・ヴァンジ彫刻美術館にて開催した「庭をめぐれば」に参加し、'時間の標本' を展示
		5月、銀座gggにて、キギ展を開催

Ryosuke Uehara Yoshie Watanabe

Y	1961	B. 1961, Yamaguchi Pref.
R	1972	B. 1972, Sapporo City Hokkaido.
Y	1984	Graduated Yamaguchi University.
Y	1986	Joined Miyata Satoru Design Office(presently DRAFT Co., Ltd.), working on advertisement and SP(sales promotion) for Lacoste for 7 years.
Y	1987	Solo exhibition at Gallery Habita, Tokyo.
Y	1989	Solo exhibition at HB Gallery, Tokyo.
Y	1992	Solo exhibition at HB Gallery, Tokyo.
Y	1995	JAGDA (Japan Graphic Designers Association) New Designer Award.
Y	1996	Book design and illustrations for the picture book Inu no Hiroshi (Rironsha), written by Taku Miki.
Y	1997	Began designing for D-BROS, a manufacturing project founded by DRAFT.
		TOKYO ADC (Art Directors Club) Award for D-BROS calendar, "PAPER TALK."
		Book design and illustrations for the picture book Sekaiichi Shiawase na Tabaco no Ki (Ehonkan), written by Natsuki Ikezawa.
R		Joined DRAFT Co.,Ltd. after graduating from Tama Art University's department of design (textiles).
R	1998	Joined D-BROS.
R&Y	1999	Launch party for restaurant and bakery shop, CASLON. Sendai City, Miyagi.
Y		Tokyo ADC Award for Mos Burger newspaper advertisement.
R	2000	Tokyo ADC Award for D-BROS packing tape, "A PATH TO THE FUTURE."
Y	2001	Elected as Tokyo ADC Member.
		"BUCH," an exhibition in collaboration with Chiaki Kasahara, at HB Gallery, Tokyo.
R&Y		Began art direction for une nana cool, an under wear shop created by Wacoal.
R		Participated in "Takeo Paper Show," an exhibition held at Spiral Hall, Aoyama, Tokyo.
		JAGDA New Designer Award.

R&Y 2002 DRAFT Co., Ltd. exhibition at ggg (Ginza Graphic Gallery) in Ginza, Tokyo.
Y NY ADC Award Gold for "BUCH."
 Art direction for Tokyo Art Directors Club Exhibition and Almanac.
R Tokyo ADC Award / Australian Young Guns Award Gold for MI·IAnAYASUHIRO 2002 A/W invitation.

R&Y 2003 Released "hope forever blossoming" (flower vase line) and "Mirror Rivulets of the Heart" (cup&saucer) for D-BROS.
Y Textile design for HaaT (ISSEY MIYAKE INC.).
R Solo exhibition "l imited" at Mihoncho Main Store, Kanda, Tokyo.
 Tokyo ADC Award for D-BROS flower vase line, "hope forever blossoming."

Y 2004 Picture book, "Brooch", published by Little More. Words by Yayako Uchida.
R Elected as Tokyo ADC Member.
 NY ADC Award Gold for D-BROS calendar, "PEACE & PIECE."
 Collaboratively wrote and published "Graphic" (Rikuyousha).
 Formed performance art group, "Murg Tikka Lawebahar," with Musubi Aoki and Saori Tsuji, beginning 21 part serialization of "Kayoujutsu" in Ryuko Tsushin.

R&Y 2005 Participated in "Takeo Paper Show" as D-BROS team at Spiral Hall, Aoyama, Tokyo.
 Began art direction for Lunch by une nana cool.
Y NY ADC Award Gold and Kodansha Publication Culture Award for "Brooch" book design.
R Art direction for Laforet Harajuku's annual image advertising.

Y 2006 English publication of Brooch.
 One Show Design Gold for Brooch.
 British D&AD GOLD for "PROPNERE" ring package.
R Book design for "Ruru Nikki" (Little More) by Mikako Ichikawa, Suiren Higashino and Eri.
 Art director for "i-X" Matsushita Electric Works bath project concept catalogue.
 Began art direction for THEATRE PRODUCTS.
 Silver Award at International Poster Biennale in Warsaw for "Decoration Laforet" image poster.
R&Y Special D-BROS exhibition, "Between G and P," at Spiral Hall.

R&Y 2007 Participated in "Chocolate," an exhibition at 21_21 DESIGN SITE, presenting the short film,
 Yokubo no Chairoi Katamari (Brown Morsels of Desire).
 Participated in "SPACE FOR YOUR FUTURE", an exhibition at the Museum of Contemporary Art Tokyo,
 presenting "Specimen of time."
Y Art Work for MIKIMOTO window display.
R Book design for "Method of THEATRE PRODUCTS" (Little More).
 Special exhibition, "Between Creation and Education", at Sky Hall Gallery, Sapporo, Hokkaido, sponsored by Mahou no Efude.

R&Y 2008 Solo exhibition of "Specimen of Time" at AMPG Gallery, Kiyosumishirakawa, Tokyo.
 Workshop, "Let's Make a Paper Watch," held at Utsunomiya Museum of Art.
Y Published Picture book "Un Deux " (Little More).
 Began art direction for SOFINA beauté.
R "FASHION/GRAPHIC," a group exhibition with Atsuki Kikuchi and Naomi Hirabayashi at G8 Gallery.

R 2009 Art direction for Tokyo's Tokyo, opening in Haneda Airport.
 Art direction for ADC exhibition and almanac.
 11th Yusaku Kamekura Design Award for Theatre Products graphic tools. Tokyo TDC Award.
 "11th Yusaku Kamekura Award Exhibition for Ryosuke Uehara" at G8 gallery (later touring in Niigata).
 Participated in "GRAPHIC TRIAL" exhibition held by Toppan Printing Co.,Ltd.
R&Y 2nd "DRAFT Exhibition" held at ggg, in Ginza.
 Art direction for PASS THE BATON, opening in Marunouchi Brick Square.
 Invited to participate in Hermès research project, "Precious Paper."

Y 2010 One Show Design Award Gold for D-BROS calendar, "ROSE."
 Textile design for UK store, Liberty's, 2010 fall-winter collection.
R NY ADC Award silver for poster designed for GRAPHIC TRIAL, "Repetition on Surface."
 Art direction for 'gredecana' brand debut and store opening in Kita-Aoyama.
 Book design for Kyoko Koizumi: "Harajuku Hyakei " (Switch Publishing).
R&Y Umbrella textile design for Netherlands company, 'senz.'
 JAGDA Award for PASS THE BATON and HOTEL BUTTERFLY graphic design.
 "Time Paper for V&A Museum", planned in collaboration between Victoria and Albert Musem (UK) and D-BROS.
 Created projected image and featured scarves for orchestral performance of the Nutcracker.

R&Y 2011 DB in STATION, D-BROS first exclusive store, opens in Shinagawa Station's 'ecute Shinagawa.'
Y Tokyo ADC Award, Tokyo TDC AWARD and JAGDA Award for D-BROS calendar, "12 Letters."
R Judge for as NY ADC Award.
 NY ADC Award Bronze for "Winnie the Pooh!" Disney product concept.
 Art direction for FACE, opening in Yurakucho Lumine.
 Judge for Chinese Graphic Design Competition, "GDC."

R&Y 2012 Creation of Kigi Co., Ltd. in Hillside terrace F, Daikanyama, Shibuya, Tokyo.
 "41st Delivery Art School" workshop, sponsored by the Alumni Association of Tama Art University,
 held in Minami Elementary School, Sakado City, Saitama.
 Participated in "Strolling the Garden," an exhibition held at The Vangi Sculpture Garden Museum,
 Clematis no Oka, presenting "Specimen of Time".
 Kigi exhibition at ggg, Ginza.

CONTRIBUTOR PROFILE

金森 香

1974年東京都生まれ。シアタープロダクツプロデューサー／プレス。セントラル・セント・マーチンズ・カレッジ・オブ・アート・アンド・デザインの批評芸術学科を卒業後、出版社リトルモア勤務を経て、2001年有限会社シアタープロダクツ設立。09年よりスペクタクル・イン・ザ・ファーム実行委員長、10年よりNPO法人ドリフターズ・インターナショナルをスタートし、理事を務める。

Kao Kanamori　B. 1974, in Tokyo. PR / Producer for THEATRE PRODUCTS. After graduating with a degree in art criticism from Central Saint Martins College of Art and Design Kao Kanamori worked for Little More publishing before later establishing THEATRE PRODUCTS Ltd. in 2001. In 2009 she became head of the executive committee for Spectacle in the Farm, and in 2010 she started the NPO, Drifters International, where she serves on the board of directors.
http://www.theatreproducts.co.jp

遠山正道

1962年東京都生まれ。株式会社スマイルズ代表取締役社長。三菱商事株式会社初の社内ベンチャーとして（株）スマイルズを設立。2008年2月MBOにて100％株式を取得。Soup Stock Tokyo、ネクタイブランドgiraffe、新しいセレクトリサイクルショップPASS THE BATONの企画・運営を行う。NY、青山などで絵の個展も開催。

Masamichi Toyama　B. 1962, Tokyo. Representative Director and President of Smiles, Co.,Ltd, which was established as the first internal venture of Mitsubishi Corporation. In February, 2008, through MBO, Mr. Toyama acquired 100% of Smiles' stocks. He runs operations and plannings for Soup Stock Tokyo, the necktie brand 'giraffe', and the new select recycle shop, PASS THE BATON. His artworks can be found exhibited in places such as NY and Aoyama.
http://toyama.smiles.co.jp

山本容子

銅版画家。1952年埼玉県生まれ、大阪育ち。京都市立芸術大学西洋画専攻科修了。都会的で軽快洒脱な色彩で、独自の銅版画の世界を確立。2007年に鉄道博物館のステンドグラス、2008年に『不思議の国のアリス』をモチーフにした東京メトロ副都心線新宿三丁目駅のステンドグラスとモザイク壁画を制作。幅広い分野で創作活動を展開している。

Yoko Yamamoto　B. 1952 in Saitama Pref and raised in Osaka. Etcher and Painter. Yoko Yamamoto completed a non-degree course in western painting at Kyoto City University of Arts. She uses light, urban tints, in order to create a world of original copperplate engravings. In 2007 she created stained glass for the Railroad Museum (JR East) and in 2008, using Alice in Wonderland as her motif, she created a stained glass and mosaic mural for the Tokyo Metro Fukutoshin-sen Shinjuku San-chome Station area. She creates across a variety of fields.
http://www.lucasmuseum.net

内田也哉子

1976年東京都生まれ。文筆業、sighboat。著者に『ペーパームービー』『会見記』、絵本『BROOCH』（絵・渡邊良重）『ラプンツェル』（絵・水口理恵子）、訳書に『たいせつなこと』（マーガレット・ワイズブラウン著）など。sighboatのボーカルもつとめる。

Yayako Uchida　B. 1976, Tokyo. Writer and sighboat. Writings include: Paper Movie, Kaikenki:An Interview Record. Picture books: Brooch (illustrations: Yoshie Watanabe), Rapunzel (illustrations: Rieko Mizuguchi). Translations: The Important Book (Margaret Wise Brown). She is also a vocalist of sighboat.

服部一成

1964年東京都生まれ。グラフィックデザイナー・アートディレクター。主な仕事に「キユーピーハーフ」の広告、「三菱一号館美術館」のロゴ、雑誌『真夜中』『here and there』『流行通信』など。作品集に『服部一成グラフィックス』（誠文堂新光社）。

Kazunari Hattori　B. 1964, Tokyo. Graphic designer and Art director. His major works include advertisements for 'Kewpie Half,' the Mitsubishi Ichigokan Museum logo, and work for magazines such as Kikan Mayonaka, here and there and Ryuko Tsushin. An anthology of his works, entitled Kazunari Hattori Graphics, is also available (Seibundo Shinkosha).

阿部海太郎

1978年生まれ。作曲家。幼い頃よりピアノ、ヴァイオリン、太鼓などの楽器に親しむ。東京藝術大学と同大学院、パリ第八大学にて音楽学を専攻。帰国後、シアタープロダクツのファッションショーや、D-BROSの映像作品の音楽を制作。現在はコンサート活動のほか、舞台をはじめ様々な分野での音楽制作に取り組んでいる。

Umitaro Abe　Umitaro Abe B. 1978. Composer. Since a very young age he has enjoyed playing the piano, violin, percussions and other instruments. He studied at Tokyo National University of Fine Arts and Music (undergrad and graduate) as well as at Université Paris 8, majoring in musicology. After returning to Japan he composed music for THEATRE PRODUCTS fashion shows, D-BROS' film production, and elsewhere. Aside from concerts, he currently works on compositions for various fields, such as for plays and films.
http://www.umitaroabe.com

宮田 識

1948年千葉生まれ。株式会社ドラフト代表。クリエイティブ・ディレクター。日本デザインセンターを経て、1978年株式会社宮田識デザイン事務所設立（89年株式会社ドラフトに社名変更）。広告・SPの企画デザインを中心に、商品開発、業態開発などの企画・プロデュースを手がける。1995年 D-BROSをスタートさせプロダクトデザインの開発・販売を開始する。

Satoru Miyata　B. 1948, Chiba. Creative director, and representative officer of DRAFT Co.,Ltd. In 1978, after working at Nippon Design Center, Inc., Miyata established Satoru Miyata Design Office (changing its name to DRAFT Co.,Ltd. in 1989). Focusing on the planning and design of ad-work and sales promotions, Miyata has been involved in production work for the development of both products and businesses. In 1995 he created D-BROS in order to develop and sell original designer products.

KIGI キギ

2012年 5月22日　初版第1刷発行
2017年10月17日　　　　第4刷発行

著者：キギ（植原亮輔と渡邉良重）

アートディレクション＆デザイン：植原亮輔、渡邉良重
テキスト：山口博之
デザインチーム：二瓶 渉（SHIROKURO.inc）、汐田瀬里菜、
　　　　　　　　井上まゆみ、小林 圭、小山麻子、
　　　　　　　　仲子なつ美、本田千尋
カバー（裏）・写真：後藤武浩
翻訳：室生寺 玲、ジェイムス・バルザー、クリストファー・ローウィー
コーディネーション：小林 望
編集：熊谷新子（リトルモア）
協力：ギンザ・グラフィック・ギャラリー

発行者：孫 家邦
発行所：株式会社リトルモア
　　　　151-0051 東京都渋谷区千駄ヶ谷 3-56-6
　　　　Tel. 03-3401-1042　Fax. 03-3401-1052
　　　　info@littlemore.co.jp　http://www.littlemore.co.jp

印刷・製本：図書印刷株式会社

株式会社 キギ
150-0033 東京都渋谷区猿楽町 18-8 ヒルサイドテラス F-203
www.ki-gi.com

©KIGI / Little More 2012
Printed in Japan
ISBN 978-4-89815-339-0　C0070

乱丁・落丁本は送料小社負担にてお取り替えいたします。
本書の無断複写・複製・引用を禁じます。
All rights reserved.
No part of this book may be reproduced.
Without written permission of the publisher.

KIGI

First published in May 2012 in Japan

KIGI (Ryosuke Uehara & Yoshie Watanabe)

Art Direction & Design : Ryosuke Uehara, Yoshie Watanabe
Text : Hiroyuki Yamaguchi
Design team : Wataru Nihei (SHIROKURO.inc), Serina Shiota,
　　　　　　　Mayumi Inoue, Kei Kobayashi, Asako Koyama,
　　　　　　　Natsumi Nakako, Chihiro Honda
Back-side cover photo : Takehiro Goto
Translation : Rei Muroji, James Balzer, Christopher Lowy
Cordination : Nozomi Kobayashi
Edit : Shinko Kumagai (Little More)
Special thanks : ginza graphic gallery (ggg)

Publisher : Sun Chiapang
Little More Co.,Ltd
3-56-6 Sendagaya, Shibuya-ku, Tokyo 151-0051, Japan
Tel. +81(0)3-3401-1042　Fax. +81(0)3-3401-1052
info@littlemore.co.jp　http://www.littlemore.co.jp

Printing & Bookbinding : TOSHO Printing Co.,Ltd

KIGI co.,ltd
Hillside terrace F-203,18-8, Sarugakucho, Shibuya-ku, Tokyo 150-0033, Japan
www.ki-gi.com

ふたりの森から。

思うに、渡邉良重は広葉樹である。彼女の作品は杏の花のようにやさしく繊細だ。彼女は、山育ちである。幼い頃に出会った木や花、生き物達、そして物語。渡邉の作品は、心の奥底に宿る自然観と感性がほとばしるがごとく表現される。それは彼女だけが持つ宇宙になっていく。

植原亮輔は針葉樹である。彼の作品はエゾマツのように凛々しく逞しい。北国育ちらしく繊細だが大胆な男らしさを持ち合わせる。気合いと根性をモットーとする。スケールの大きい思考を持つ。卓越したアイデアマンである。ディテールにとことんこだわる。これらが植原の頭の中に描く世界を完璧にまで具現化する。進化する彼のデザインは未知数の可能性を秘めている。

2人はまるで兄妹のようである。お互いの感性が関わり合う事で影響しあい飛躍する。「キギ」を2人で創設した。いままでに無いデザインがふたりの森から誕生する日を期待する。

DRAFT 宮田 識

From the forest of Ryosuke Uehara and Yoshie Watanabe.

Yoshie Watanabe is like a broad-leafed tree. Her works, like the flowers of an apricot, are soft and delicate. Raised in the mountains, from a young age she made acquaintance with the trees, the flower, the animals, and of course, with fairy-tales. In the works she produces this sensibility and sense of nature which dwells in her heart seems to gush forth exuberantly, transforming into a cosmos of her own keeping.

Ryosuke Uehara would be a conifer. Like a spruce tree, his works are intense and bold. While they possess a level of sensitivity characteristic of a person raised in the Northern provinces, they are simultaneously audacious and masculine. Guts and determination as his watchword. He thinks big, an idea man of the first order and obsessive to a fault over details. It is these traits which allow him to breathe perfect life into the world painted inside his head. As his designs evolve, they continue to show ever unlimited potentials.

Together, the two remind me of brother and sister. Their close influence, one upon the other, allows them to proceed by leaps and bounds. Kigi was created by the both of them. I wait with great anticipation to see what new designs, heretofore unknown, will emerge from this forest they have created.

Satoru Miyata DRAFT